THE NAVAJO ART OF SANDPAINTING

Douglas Congdon-Martin

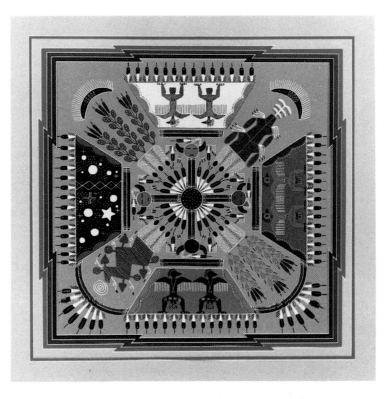

Schiffer Publishing Ltd

1469 Morstein Road, West Chester, Pennsylvania 19380

Dedication

To my mother and father, keepers of the faith.

Published by Schiffer Publishing, Ltd.
1469 Morstein Road
West Chester, Pennsylvania 19380
Please write for a free catalog.
This book may be purchased from the publisher.
Please include $2.00 postage.
Try your bookstore first.

Copyright © 1990 by Schiffer Publishing, Ltd.
Library of Congress Catalog Number: 90-61507.

All rights reserved. No part of this work may be reproduced or used in any forms or by any means—graphic, electronic or mechanical, including photocopying or information storage and retrieval systems—without written permission from the copyright holder.

Printed in the United States of America.
ISBN: 0-88740-271-2

Title page photo:
Unknown artist. "Four Seasons," traditional, 16″ x 16″. *Courtesy of Foutz Trading Company, Shiprock, N.M.*

Acknowledgments

Many people have welcomed us into their shops and homes as we gathered information and photographs for this book. We thank them all for their contributions. You will find their names listed below, and we have included the addresses of those with businesses where you will find sandpaintings for sale. Credits are given with each of the photographs.

Most of the fine photos were taken by Herbert and Peter Schiffer. I thank them for capturing the beauty of these figures on film.

Our sincere thanks go to:

Arroyo Trading Co., Vince and Helen Ferrari, 2111 W. Apache, Farmington, New Mexico

Erik and Ailene Bromberg

Bing Crosby's Indian Art, Inc., Bing Crosby, 2510 Washington NE, Albuquerque, New Mexico

Foutz Trading Company, Bill and Kay Foutz, Shiprock, New Mexico

Indian Traders West, Tommy Elkins; Willa, Tom, and Brett Bastien, 204 W. San Francisco St., Sante Fe, New Mexico

The Indian Post, Carolyn Foreback, Sovereign Building, 609 Hamilton Mall, Allentown, Pennsylvania

Shiprock Trading Post, Ed and Jeff Foutz, Shiprock, New Mexico

Turquoise Lady, Mary and Cathren Harris, 2012 Plaza Drive, SW, Albuquerque, New Mexico

Unknown artist. Sandpainting and carved figures. *Courtesy of Shiprock Trading Company, Shiprock, NM.*

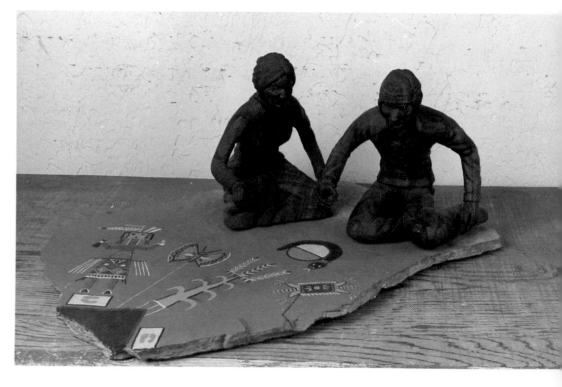

The Art of Navajo Sandpainting

Historic Roots of Navajo Sandpainting

The beginnings of the art of sandpainting are lost in history. Until recently it has been used only as an impermanent but important part of the Navajo religious life. The sandpaintings are drawn with painstaking care by the singer. Often referred to as the medicine man by the outside world, the "hatááli" is a highly trained practitioner of the Navajo religious knowledge and practice. Sandpaintings are part of the rituals which call the Holy People, creating an altar where sacramental activities take place. At the appropriate time in the singing the sandpainting is made on the floor of the hogan. The images in the painting, along with the singing, attract the Holy People to the ceremony. The "patient" (the one for whom the ceremony is being sung) sits on the sandpainting facing east. The singer takes sand from figures in the sandpainting and applies them to the patient in a prescribed manner. In this way the power of the Holy People is transferred to the patient for healing or blessing. When the ceremony is complete the sandpainting is carefully "erased." The sand is gathered into a blanket and safely deposited north of the hogan, to protect others from contamination.

It is generally thought that the Navajos learned the basics of the art of sandpainting from the Pueblo Indians when they came to the Southwest. Seeing the designs and techniques of the inhabitants of the regions, they brought their own imaginative, artistic genius to bear and developed sandpainting into a creative part of their religious ceremonies.

Leland C. Wyman, who has contributed so much to the study of sandpainting, modifies this understanding (*Southwest Indian Sandpainting*, University of New Mexico Press). While it certainly was influenced by the Pueblo Indians, he suggests that the original medium was not impermanent sand, but rock. Early Navajo pictographs have been found painted on or incised into rock, which include many of the figures and symbols used in Navajo sandpainting. These rock paintings are found in the Navajo homeland of Dinetah and date from the Gobernador Phase of Navajo occupation (A.D. 1696-1775). During this time when the Navajo migrated to their present home and had a great deal of interaction with the Pueblo Indians, who were recoiling after their unsuccessful rebellion against Spanish domination of circa 1680 (Wyman, pages 36-37).

Wyman suggests that the shift from the permanent rock art to the impermanent sand art was primarily a response to the intrusive presence of the Spanish and Anglo cultures. It is clear that these colonialists had little respect for the religious traditions of the Native Americans, and brought a great deal of pressure on them to abandon their "heathen" practices. The result was the growth of patterns of secrecy surrounding these ceremonies.

The art of sandpainting was brought to public recognition in the late nineteenth century by Washington Matthews, an army doctor who was stationed at Fort Wingate. He heard about sandpaintings from a Mexican prisoner named Jesus Arviso in 1880. In 1884 he witnessed a Mountainway ceremony at Hard Earth, New Mexico. He was given access to the ceremonial hogan and made sketches of the sandpaintings that were used. To have the sandpaintings sketched caused some furor among those present, but Matthews later reported that once it was learned that he had sketches in his possession, "it was not uncommon for the shamans, pending a performance of a ceremony, to bring young men who were to

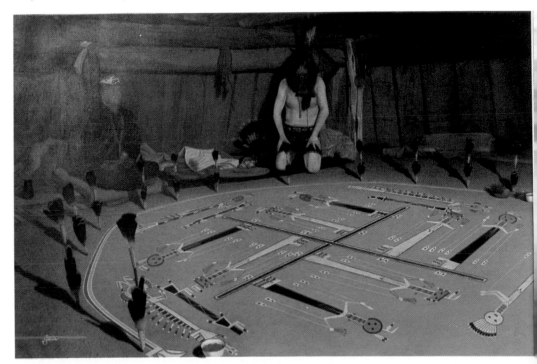

David Yazzie. "Sandpainting Ceremony," oil painting on canvas, 24″ x 36″. *Courtesy of Indian Traders West.*

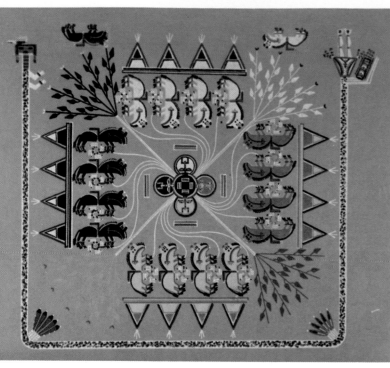

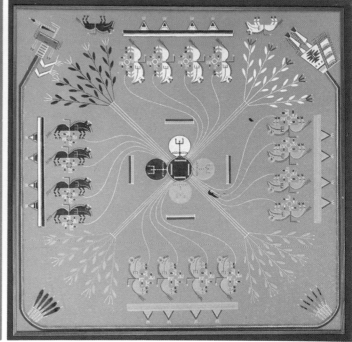

Miguelito. "The Home of the Buffalo People," reproduced in *Navajo Medicine Man; The Sandpaintings of Miguelito*, Gladys A. Reichard, J.J. Augustin, N.Y., 1939. *Courtesy of Foutz Trading Company.*

Unknown artist. "Home of the Buffalo People." Notice the similarity with Miguelito's rendition. Reichard's books became patterns for people wishing to do traditional sandpaintings. *Courtesy of Bing Crosby's, Albuquerque.*

assist to the lodge, ask to see the paintings, and lecture on them to their pupils..." (quoted in *Navajo Sandpainting*, Nancy J. Parezo, University of Arizona Press, 1983, page 69).

The secrecy surrounding sandpainting began to lift, if only a little, although there still was an aura of fear and distrust about making the paintings permanent. Matthews overcame some of that through the respect he showed to the traditions, including hiding the paintings during the "forbidden season" (summer, when snakes and lightning were present) and never showing them to tribe members who were "uninitiated"—had not been sung over (Parezo, p. 69).

Despite Matthews' work, some thirty years would pass before any serious research would be undertaken. Three Anglo-American women and two singers cooperated to open the art of sandpainting to a larger public. Franc J. Newcomb, a traders wife, was a friend of Hosteen Klah, an accomplished and well-known singer who knew at least four chants. He invited Newcomb to her first sing in 1917. She carefully observed all that happened and later tried, unsuccessfully, to reproduce the sandpaintings from memory. Klah helped by drawing the patterns in pencil, which Newcomb then reproduced in watercolors. After seeing that no harm came to her or to himself, Klah drew some twenty-seven sandpaintings for her in 1917 and 1918, explaining the symbolism as he went.

Gladys A. Reichard undertook her study of sandpainting in the mid to late 1920s. She had inherited the task of preparing the myth of the Male Shooting Chant for publication. As she tells it, "I could not help but feel that this myth was just so many words which could not become the living thing those words indicated unless through experience, comprehension could be put into them." (*Sandpaintings of the Navajo Shooting Chant*, Newcomb & Reichard, Dover Publications, 1975, page 2).

She went about gaining this experience passionately, learning the Navajo language and for five summers placing herself in an apprentice-like relationship to a singer. The singer was Miguelito, or Red Point, and Reichard lived with his family "to try to live as

nearly as they do as possible, and through accumulating experience and often fortuitous moments of comprehension, to attempt to regard matters in the Navajo spirit" (Reichard, p. 2). Miguelito was a great teacher, and provided Reichard with the experience she sought. Their cooperative efforts are still a primary of source of insight into sandpainting more than fifty years after their publication.

The third Anglo-American woman to contribute to the wider appreciation of sandpainting was Mary Cabot Wheelwright. A friend of the Newcombs, she met Hosteen Klah and witnessed her first ceremony in 1925. Klah urged her to build a museum to hold the artifacts of Navajo ceremonial culture. In 1935 the Museum of Navajo Ceremonial Art was founded in Santa Fe.

For these five pioneers, and many others, the motivation for abandoning the tradition of secrecy and risking the consequences of that abandonment was the preservation of Navajo tradition. Seeing the encroachment of the white culture on the Navajo community and a decline of interest among the young, they were genuinely concerned that the rich religious tradition may have been lost. They were pressed by time to gather as many rituals, myths, and paintings as they could before they disappeared forever.

From Religious Artifact to Collectible Art

Even while the ethnologists were gathering sandpainting reproductions for museums and scholarly pursuits, others were recognizing the aesthetic impact of sandpaintings and their desirability as collectible art. The idea of having a sandpainting as a work of art to hang on the wall appealed to many people, and some built sizable and significant collections.

Both museums and individuals were limited at first to representations of sandpaintings done in pencil, watercolor, or other medium on paper. Some museums collected actual sandpaintings in permanent, protected exhibitions, but most of these fell victim to their fragility.

Marian Rodee reports that sandpainting designs were woven into rugs as early as 1883 (*Weaving of the Southwest*, Schiffer Publishing, 1987, page 149). She speculates that in view of the seemingly peaceful introduction of these rugs, they may have been for the purposes of the preservation of tradition, much as the early paper reproductions of sandpaintings. Things were not as peaceful when a rug depicting a Yei was hung in a trader's office, sometime between 1900 and 1915, near Farmington, New Mexico. Rodee suggests that one of the first may have been woven by Yana pah, the Navajo wife of Richard T.F. Simpson, a trader at Canyon Gallegos near Farmington, New Mexico. When it was put up for sale, the local Navajo were furious. Rodee attributes their furor to the feeling that when "the single yei rug appeared on the wall or floor of a trading post with a price...its only purpose was to decorate a collector's home or be walked on. Thus it had no 'redeeming social value' and represented a real misuse of power." (Rodee, page 149) The yei rugs sold to collectors for several hundred dollars, high prices for rugs in that day, which may have helped overcome the initial furor or at least encouraged the weavers to continue despite the uproar. Also key to the Navajo's eventual acceptance of sandpainting designs as an art form was Hosteen Klah's weaving of sandpainting rugs, which began in 1919. In any case the traders encouraged their continued weaving.

The spiritual objection to making sandpaintings designs as public or permanent art works was one of the barriers that had to be crossed before they could become commercially successful. Real sandpaintings were powerful religious works. They were used to summon the Holy People to help meet the needs of the Earth People for healing and assistance. Their misuse, many believed, could result in retribution and sickness. Among the possible consequences faced by the singer, weaver, or painter, whether Anglo or Navajo, were blindness, insanity, paralysis, and crippling (Parezo, page 63).

Guarding against these consequences and avoiding violations of their religious standards were very important considerations for the Navajo. They developed a rationalization for sandpainting art that managed to appease their religious misgivings about producing the painting and about sharing it with the larger world. As Parezo explains, "This rationalization stemmed from the belief that completeness and accuracy were the crucial factors in sanctification of sandpaintings. They argued that [the] simple device of changing details would prevent the Holy People from being called and impregnating the painting with power." (Parezo, page 75) In effect, the altered sandpainting would remain in the secular world.

As an added precaution, early sandpainting reproductions were made only by singers or their family members who came under their protection. Protective ceremonies were performed for weavers of sandpainting-design rugs. As time has passed and there has been no great outbreak of misfortune, the precautionary activities have gradually diminished in importance.

Another major barrier to the commercialization of sandpainting art was the medium itself. Paper or woven representations of sandpainting designs were not able to capture the depth and subtle structure of the sandpainting, nor did they accurately portray the talent of the artist. Until about 1932, however, there was no practical way to make an actual sandpainting permanent.

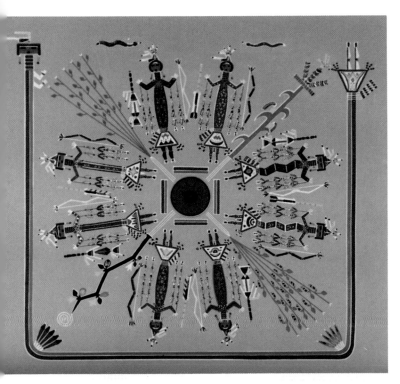

Miguelito. "The Red Snake People from Red Mountain," reproduced in *Navajo Medicine Man; The Sandpaintings of Miguelito,* Gladys A. Reichard, J.J. Augustin, N.Y., 1939. *Courtesy of Foutz Trading Company.*

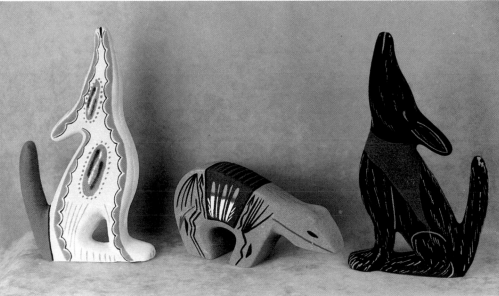

Unknown artist. Sandpainted figures. *Courtesy of Arroyo Trading Co., Farmington, NM.*

Parezo credits four people with the development of a way to preserve sandpaintings as art, and the following descriptions depend on her report. Two of them, E. George de Ville and Mae Allendale de Ville, were artists who, because of the Great Depression, found themselves traveling from place to place painting signs, redecorating homes and public buildings, and trying to sell their paintings. Finally, in 1932, they were stranded in Gallup, New Mexico, with a broken-down car and no money to repair it. They supported themselves with odd jobs.

Mae became friends with a Navajo singer and was allowed to witness a dozen ceremonies. Fascinated and inspired, she devised a technique for making permanent paintings, utilizing an adhesive of varnish, white lead and raw oil on a wallboard backing. Onto this she sprinkled natural sands of various colors in the patterns she had witnessed at the ceremonies. The paintings found an eager market almost immediately. She soon introduced realistic designs in the sandpainting medium, developing her skill as she went. By 1938 her work had reached such a level of popularity that she stopped making traditional designs.

George, who had been somewhat skeptical of the medium of sandpainting, soon took up the art himself. With his formal training he soon was using sand as an alternative to oil in producing fine art. Together Mae and George became quite renowned as western artists, and were the first to be successful at commercial sandpainting.

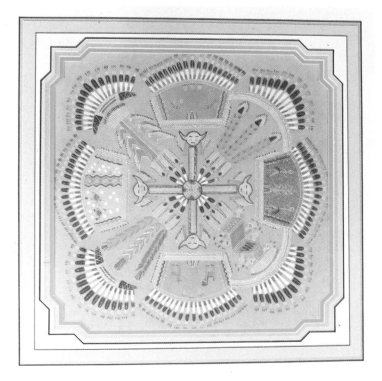

Unknown artist, 1989. "Storm Figure," traditional sandpainting using pastel tones, 16″ x 16″. Compare with Miguelito's colors or with the "Four Seasons" sandpainting following. *Courtesy of Foutz Trading Company, Shiprock, NM.*

Fred Stevens, Jr., a Navajo friend of George de Ville, would often watch him as he worked. But because George carefully guarded his adhesive formula and because it would have been against Navajo values to take the formula without permission, Stevens began to experiment on his own. His objective was much the same as that of his clan grandfather, Hosteen Klah: to preserve Navajo tradition. Stevens was an accomplished singer, and as a professional sandpainting demonstrator at a small private museum, he became recognized as one of the most talented. Eventually his skill would take him around the world, demonstrating his art.

He began his search for a way of making permanent sandpaintings in 1946, and while some admittedly mediocre paintings were sold in the experimental years, the real breakthrough came in the early 1950s. He had moved with his family to Tucson, where he continued to demonstrate the art of sandpainting. One of his new friends was and artist and U.S. Air Force pilot named Luther A. Douglas.

An interest in sandpainting and Navajo culture developed during childhood probably drew Douglas to Stevens. Douglas had been working with sandpainting as art since his school days. Beginning in the early 1950s, he and Stevens worked to solve the problem of permanency. They developed a technique using three-ply plywood as a base and a combination of shellac, glue, and paste as the adhesive. This was a big step forward and Stevens began to use the technique for his traditional paintings while Douglas explored new forms and new materials.

Neither the de Villes nor Douglas had a direct influence on Navajo commercial sandpainting. That was left to Stevens. His career and reputation continued to grow, and he developed the technical side of his art to perfection, first by using a solution of Duco™, and then in 1959 or 1960 using the slower drying "white glue." This white glue method is now used by practically all sandpainting artists.

Stevens's influence on Navajo sandpainting was documented by Parezo. When her study was terminated in 1979, she had identified 451 sandpainters by name. Of those 302 could be traced back to Fred Stevens, Jr. as the ultimate learning source (Parezo, page 121). In the years since then, we know that his influence has grown even more.

Contemporary Sandpaintings

Sandpaintings continue to fall into two basic types: traditional sandpainting designs and sand art. Traditional sandpainting continues to use the subjects and forms that come from the religious ceremonies. The rationalization that enabled the Navajo to share these images with the world by changing them slightly has also allowed them to alter the colors to appeal to the tastes of the consumer. Hence, in addition to traditional colors, ceremonial sandpaintings often are made in colors that would never be seen on the hogan floor, but would look wonderful in the modern living room or board room.

Many of the artists have gone beyond the traditional forms to use sand as the medium of more creative fine art. Eugene Baatsoslanii Joe, J.M. Cambridge, Jerald Sherman, Margaret and George John, and many others are treating cultural themes which draw upon traditional images, but treat them in new, freer ways.

Some Anglo art critics see this as a development away from a primitive folk art and toward a fine art. While this may be true, in fact both traditional and nontraditional sandpaintings show a vast range of talent and quality. Both forms include simple paintings priced at a few dollars and aimed at the tourist market, to complex paintings costing thousands of dollars destined for the collections of the most discerning of connoisseurs of the fine arts.

As is evident from the examples in this book, each artist brings his or her own insight and perspective to their work, even when it is a traditional subject. This is, of course, to be expected. What is perhaps more remarkable is the way the essence of the traditional sandpainting is preserved from artist to artist. It is a testament to the power of these images and the commitment of the artist to be faithful to the ways of their religion.

Listed alphabetically
Sandpainters and Their Works

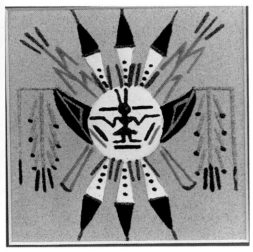

Allen. "Sun Shield," traditional, 4″ x 4″. *Courtesy of Foutz Trading Company, Shiprock, NM.*

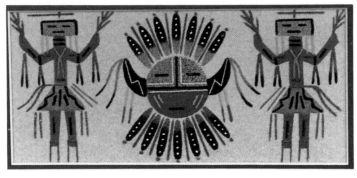

L. B. "Sun and Yeis," traditional, 4″ x 8″. *Courtesy of Foutz Trading Company, Shiprock, NM.*

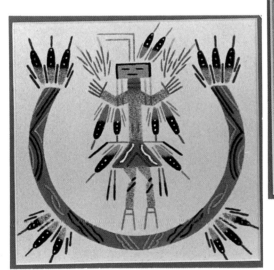

J. B. Traditional sandpainting, 12″ x 12″. *Courtesy of Foutz Trading Company, Shiprock, NM.*

L. B. "East People and Corn," traditional, 13″ x 13″. *Courtesy of Foutz Trading Company, Shiprock, NM.*

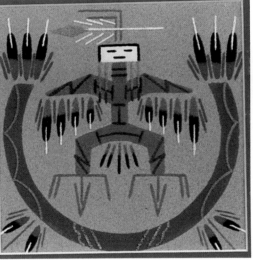

L. B. "Thunder," traditional, 6″ x 6″. *Courtesy of Foutz Trading Company, Shiprock, NM.366*

Wilfred Bahe. "Four Seasons," traditional, 18″ x 18″. *Courtesy of Foutz Trading Company, Shiprock, NM.*

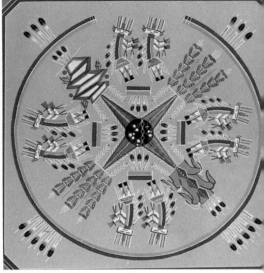

Fae Beagh. "From a Navajo religious ceremony," traditional. *Courtesy of Bing Crosby's, lbuquerque.*

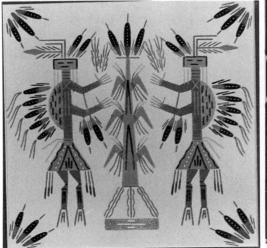

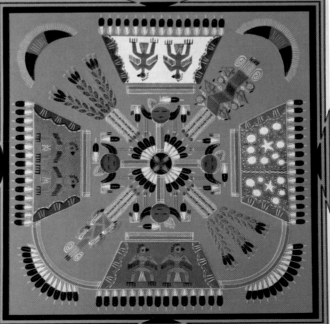

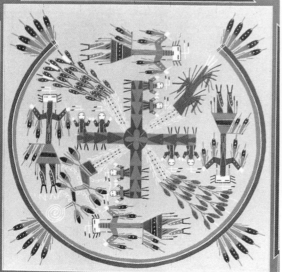

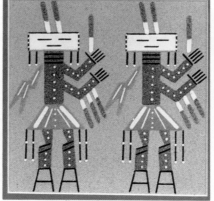

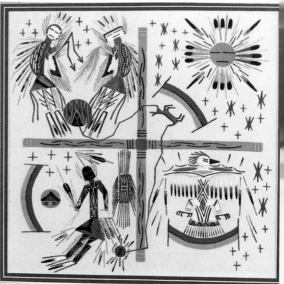

Begay. "Whirling Log," traditional, 16″ x 16″. *Courtesy of Foutz Trading Company, Shiprock, NM.*

Harold Begay. "Female Dancers," traditional, 6″ x 6″. *Courtesy of Foutz Trading Company, Shiprock, NM.*

J. Begay, 1989. Traditional sandpainting, 16″ x 16″. *Courtesy of Foutz Trading Company, Shiprock, NM.*

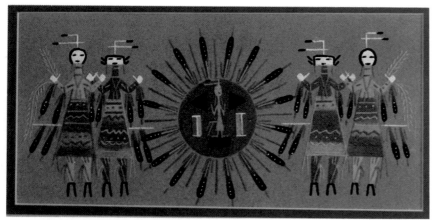

Beverly Begay. Traditional sandpainting, 6″ x 12″. *Courtesy of Foutz Trading Company, Shiprock, NM.*

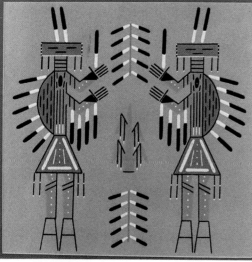

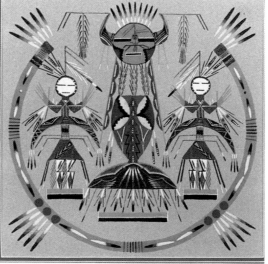

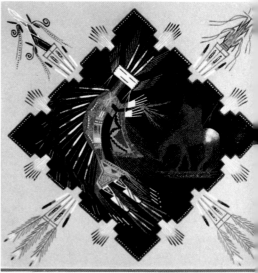

Harold Begay. "Two Female Yei with Corn," traditional, 12″ x 12″. *Courtesy of Foutz Trading Company, Shiprock, NM.*

J. Begay, 1989. Traditional sandpainting, 18″ x 18″. *Courtesy of Foutz Trading Company, Shiprock, NM.*

James and Val Begay. Sand art using three themes: "Whirling Log Rain," "End of the Trail," and "Four Sacred Plants," 16″ x 16″. *Courtesy of Foutz Trading Company, Shiprock, NM.*

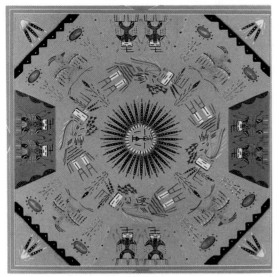

P. Begay, Sheep Spring. "Sun, Eagle and Rainbow Yei," traditional, 16″ x 16″. *Courtesy of Foutz Trading Company, Shiprock, NM.*

H.R. "War Eagle" Begaye. "Winter in Navajo Land," sand art, 12″ x 12″. *Courtesy of Foutz Trading Company, Shiprock, NM.*

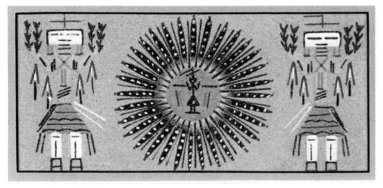

P. Begay, Sheep Spring. "Sun and Eagle with Yei," traditional, 4″ x 8″. *Courtesy of Foutz Trading Company, Shiprock, NM.*

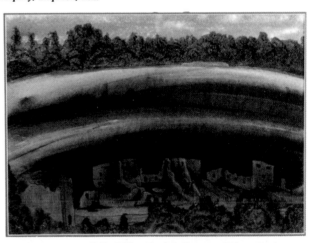

H.R. "War Eagle" Begaye. "Mesa Verde (Spruce Tree Ruin), sand art, 12″ x 16″. *Courtesy of Foutz Trading Company, Shiprock, NM.*

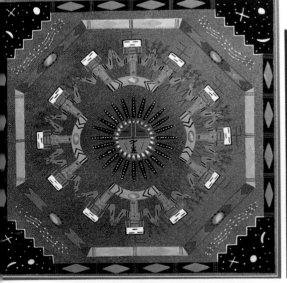

P. Begay, Sheep Spring. "Charicha Sun with Whirling Yeis," traditional, 16″ x 16″. *Courtesy of Foutz Trading Company, Shiprock, NM.*

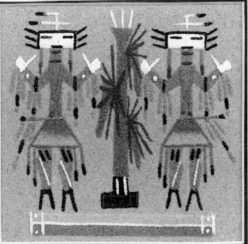

R. Begay. "Yei Be Chai and Corn," traditional, 4″ x 4″. *Courtesy of Foutz Trading Company, Shiprock, NM.*

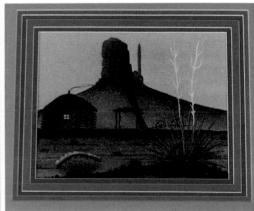

H.R. "War Eagle" Begaye. "Log Cabin and Shiprock," sand art. *Courtesy of Foutz Trading Company, Shiprock, NM.*

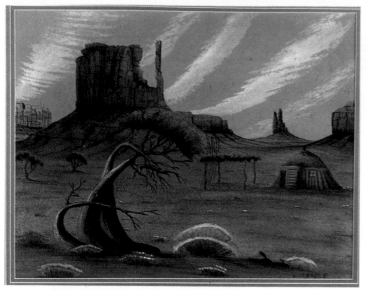

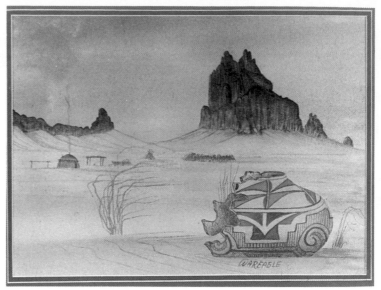

H.R. "War Eagle" Begaye, Shiprock, NM. "Monument Valley," sand art, 16″ x 20″. *Courtesy of Foutz Trading Company, Shiprock, NM.*

H.R. "War Eagle" Begaye. "Winter Scenery," sand art, 8″ x 10″. *Courtesy of Foutz Trading Company, Shiprock, NM.*

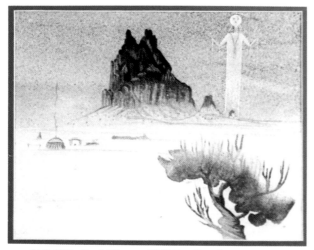

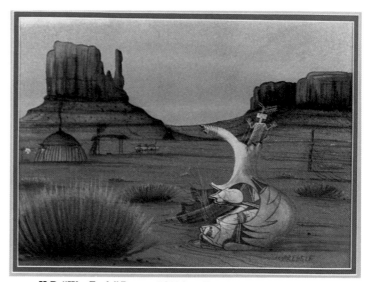

H.R. "War Eagle" Begaye. "Old Ones," sand art, 12″ x 6″. *Courtesy of Foutz Trading Company, Shiprock, NM.*

H.R. "War Eagle" Begaye. "Night Scenery, Monument Valley," sand art, 16″ x 20″. *Courtesy of Foutz Trading Company, Shiprock, NM.*

H.R. "War Eagle" Begaye. "Old Ones," sand art, 12″ x 16″. *Courtesy of Foutz Trading Company, Shiprock, NM.*

H.R. "War Eagle" Begaye . "Spirit of the Flute Player," sand art, 12″ x 12″. *Courtesy of Foutz Trading Company, Shiprock, NM.*

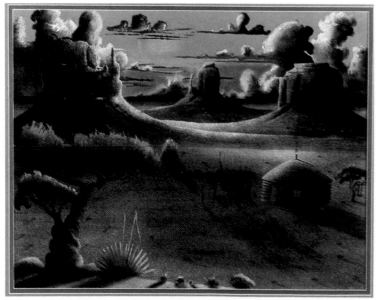

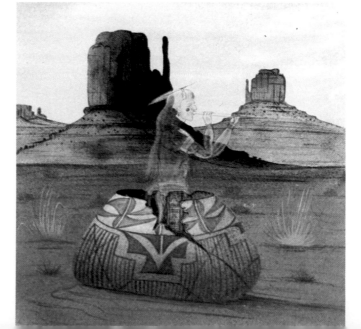

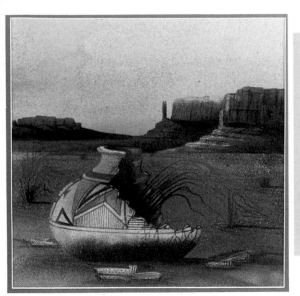

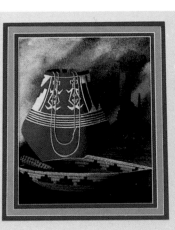

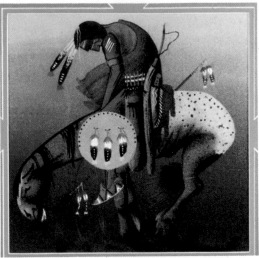

H.R. "War Eagle" Begaye. "Sunset," sand art, 12″ x 12″. *Courtesy of Foutz Trading Company, Shiprock, NM.*

H.R. "War Eagle" Begaye. Sand art. *Courtesy of Foutz Trading Company, Shiprock, NM.*

H.R. "War Eagle" Begaye. "End of the Trail," sand art, 12″ x 12″. *Courtesy of Foutz Trading Company, Shiprock, NM.*

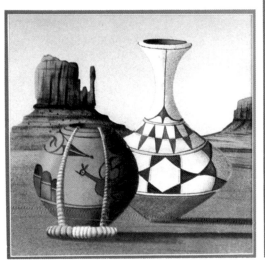

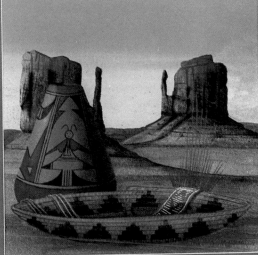

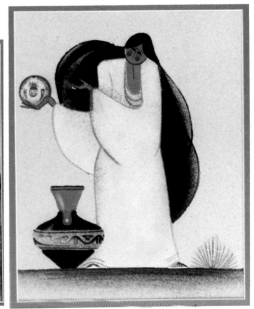

H.R. "War Eagle" Begaye. "Pottery," sand art, 12″ x 12″. *Courtesy of Foutz Trading Company, Shiprock, NM.*

H.R. "War Eagle" Begaye. "Still Life," sand art, 12″ x 12″. *Courtesy of Foutz Trading Company, Shiprock, NM.*

H.R. "War Eagle" Begaye. "San Defonso Lady," sand art, 10″ x 8″. *Courtesy of Foutz Trading Company, Shiprock, NM.*

H.R. "War Eagle" Begaye. "Medicine Man," sand art, 16″ x 20″. *Courtesy of Foutz Trading Company, Shiprock, NM.*

H.R. "War Eagle" Begaye. "Monument Valley, Utah," sand art. *Courtesy of Foutz Trading Company, Shiprock, NM.*

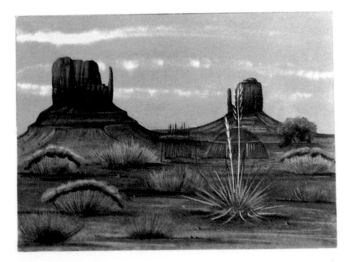

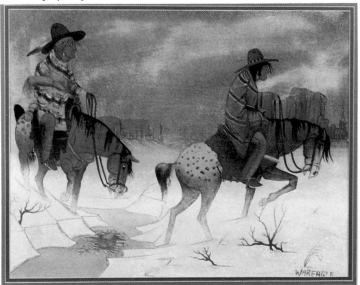

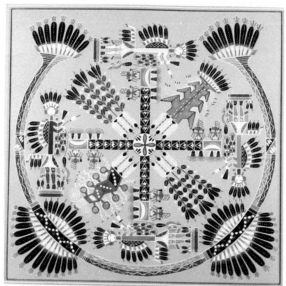

Darrell Ben. "Whirling Logs," traditional, 18″ x 18″. *Courtesy of Arroyo Trading Co., Farmington, NM.*

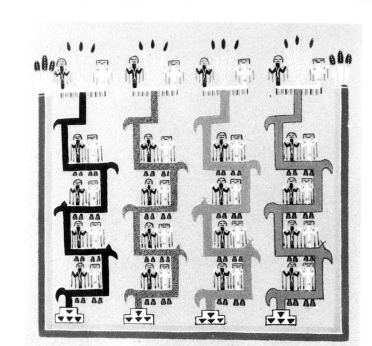

G. Ben. "Angled Corn with Yei," traditional. Twenty pairs of male and female yei sitting on tassels and horizontal portion of the stalk of corn plants, 12″ x 12″. *Courtesy of Shiprock Trading Company, Shiprock, NM.*

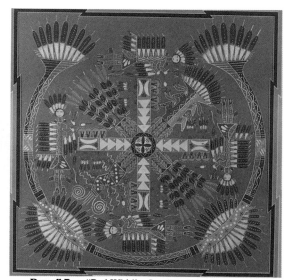

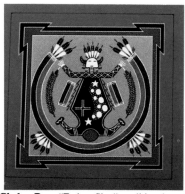

Gladys Ben. "Father Sky," traditional sand-painting. *Courtesy of Foutz Trading Company, Shiprock, NM.*

Darrell Ben. "Red Whirling Log," traditional, 16″ x 16″. *Courtesy of Foutz Trading Company, Shiprock, NM.*

Darrell Ben, 1987. "Mother Earth," traditional. *Courtesy of Foutz Trading Company, Shiprock, NM.*

Herbert Ben, Sr., 1985. "Storm Figure, Rain and Lightning," traditional, 24″ x 24″. *Courtesy of Shiprock Trading Company, Shiprock, NM.*

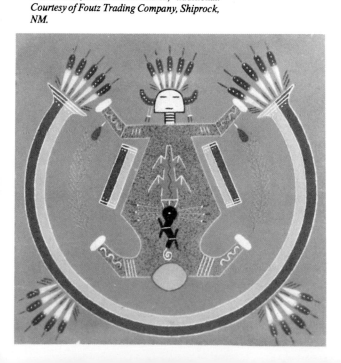

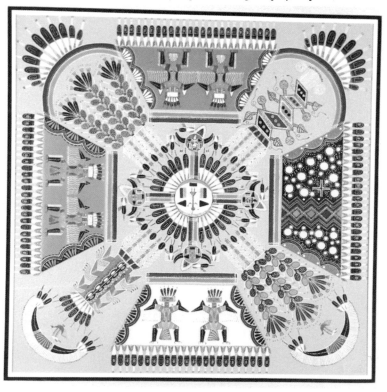

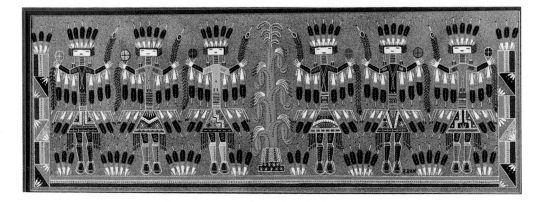

Herbert Ben, Sr. 1982. "Yei Bei Chei Corn Dancers," traditional, 9″ x 24″. *Courtesy of Shiprock Trading Company, Shiprock, NM.*

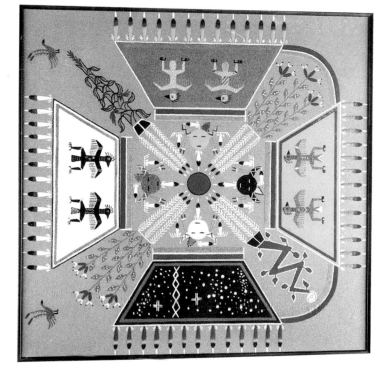

Herbert Ben, Sr. "Storm Figures, Rain and Lightning," traditional, 24″ x 24″. *Courtesy of Shiprock Trading Company, Shiprock, NM.*

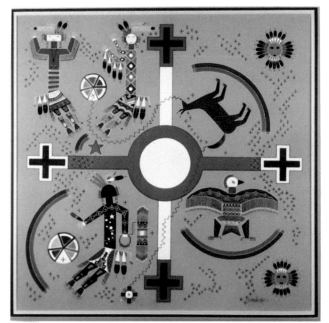

Joe Ben, Jr. "Coyote Stealing Fire," traditional sandpainting, 24″ x 24″. *Courtesy of Arroyo Trading Co., Farmington, NM.*

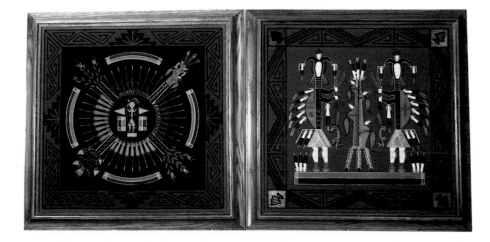

R. Ben and T. Benally. Two traditional sandpaintings. *Courtesy of Foutz Trading Company, Shiprock, NM.*

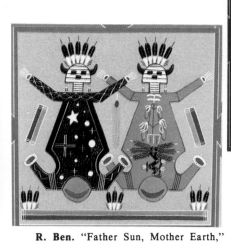

R. Ben. "Father Sun, Mother Earth," traditional sandpainting. *Courtesy of Foutz Trading Company, Shiprock, NM.*

R. Ben. "Sun," traditional. *Courtesy of Foutz Trading Company, Shiprock, NM.*

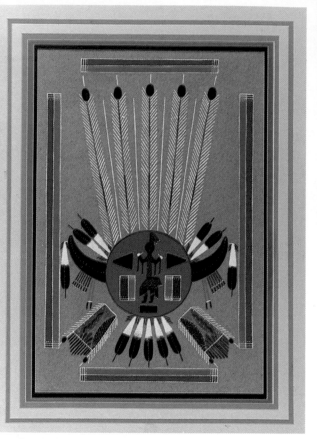

R. Ben. "Sun," traditional. *Courtesy of Foutz Trading Company, Shiprock, NM.*

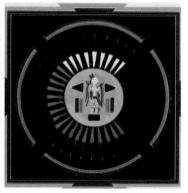

R. Ben. "Sun," traditional. *Courtesy of Foutz Trading Company, Shiprock, NM.*

Rosabelle Ben, 1984. "Sun Verse," traditional, 18″ x 12″. *Courtesy of Foutz Trading Company, Shiprock, NM.*

Rosabelle Ben, 1986. "Yei-Be-Chai," traditional, 12″ x 6″. *Courtesy of Foutz Trading Company, Shiprock, NM.*

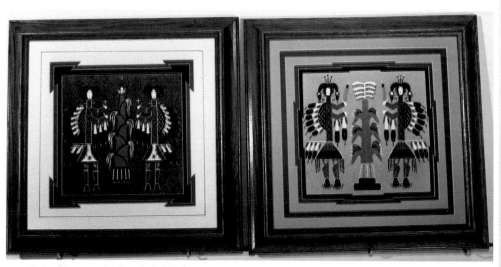

R. Ben. Two traditional sandpaintings. *Courtesy of Foutz Trading Company, Shiprock, NM.*

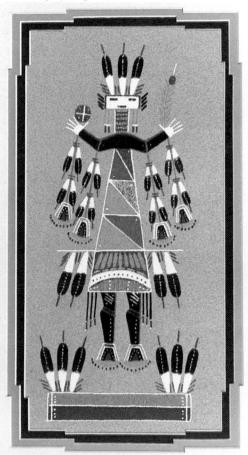

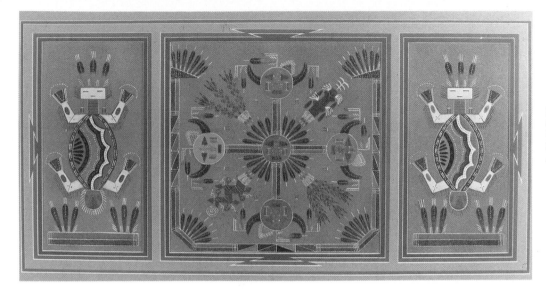

Rosabelle Ben, 1989. In this traditional sandpainting the side panels represent Water Creatures and the center panel is "The Four Houses of the Sun," 12″ x 12″. *Courtesy of Foutz Trading Company, Shiprock, NM.*

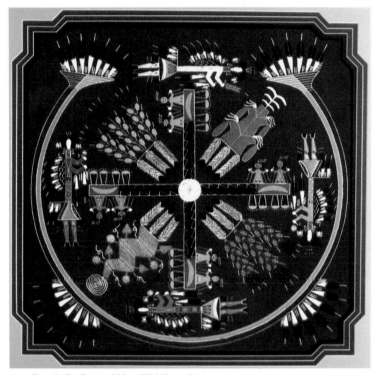

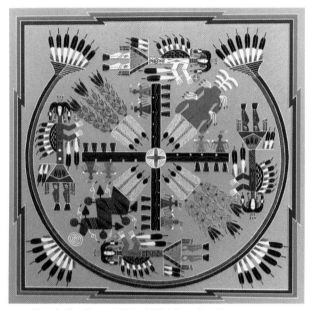

Rosabelle Ben, 1989. "Whirling Log," traditional, 16″ x 16″. *Courtesy of Foutz Trading Company, Shiprock, NM.*

Rosabelle Ben. "Sky People," used in marriage services, traditional, 18″ x 18″. *Courtesy of Shiprock Trading Company, Shiprock, NM.*

Rosabelle Ben, 1989. "Whirling of Logs," traditional, 16″ x 16″. *Courtesy of Foutz Trading Company, Shiprock, NM.*

Rosabelle Ben. "Five Yei," traditional. *Courtesy of Foutz Trading Company, Shiprock, NM.*

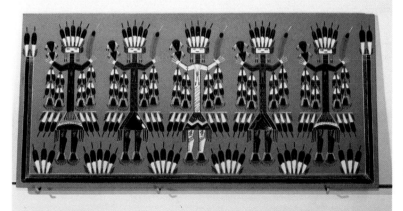

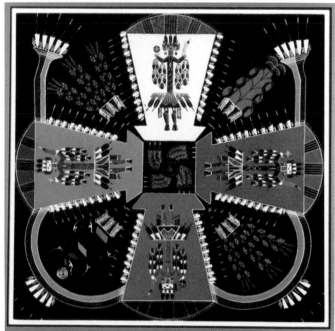

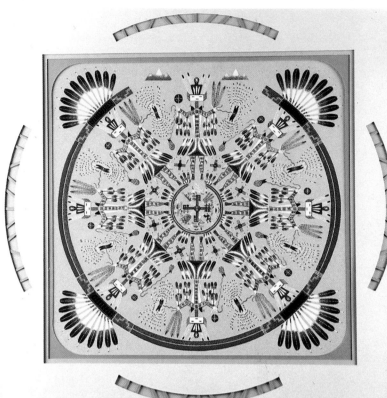

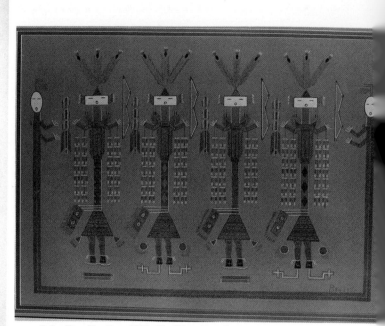

John Benally, Sr., 1989. Traditional sand-painting, 18″ x 24″. *Courtesy of Foutz Trading Company, Shiprock, NM.*

Wallace Ben . "Feather Chant with Whirling Log Center," traditional, 18″ x 18″. The Feather Chant takes place in nine day and night chants. This painting is made on the seventh day. *Courtesy of Shiprock Trading Company, Shiprock, NM.*

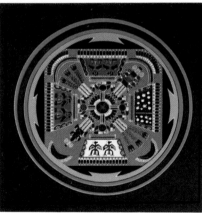

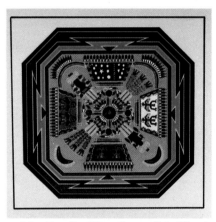

John Benally. "Four Seasons," traditional. *Courtesy of Foutz Trading Company, Shiprock, NM.*

John Benally. "Four Seasons," traditional. *Courtesy of Foutz Trading Company, Shiprock, NM.*

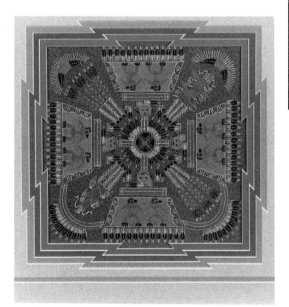

John Benally, Sr., c. 1985. "Four Houses of the Sun," traditional, 6″ x 6″. *Courtesy of Foutz Trading Company, Shiprock, NM.*

John Benally. Traditional sandpainting. *Courtesy of Foutz Trading Company, Shiprock, NM.*

John Benally, Sr. "Storm Figures," traditional, 12″ x 12″. *Courtesy of Foutz Trading Company, Shiprock, NM.*

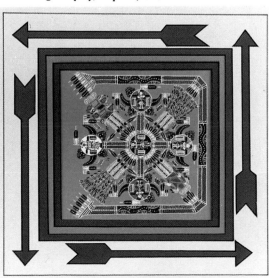

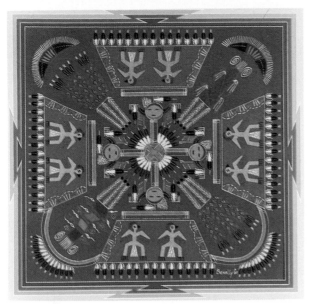

Johnny Benally, Sr., 1989. "Whirling Log," traditional, 16″ x 16″. *Courtesy of Foutz Trading Company, Shiprock, NM.*

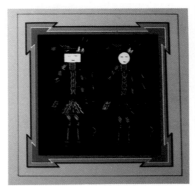

John Benally, Jr. Traditional sandpainting. *Courtesy of Foutz Trading Company, Shiprock, NM.*

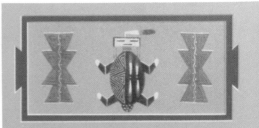

Phil Benally. "Water Creature with Bar," traditional, 4″ x 8″. *Courtesy of Foutz Trading Company, Shiprock, NM.*

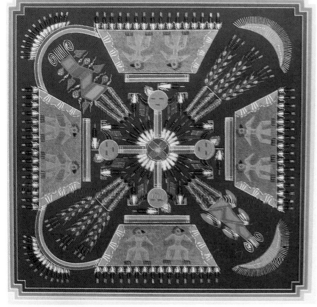

John Benally, Sr., 1989. "Storm Pattern," traditional, 18″ x 18″. *Courtesy of Foutz Trading Company, Shiprock, NM.*

John Benally, Jr. "Yei Females with Corn," traditional, 12″ x 12″. *Courtesy of Foutz Trading Company, Shiprock, NM.*

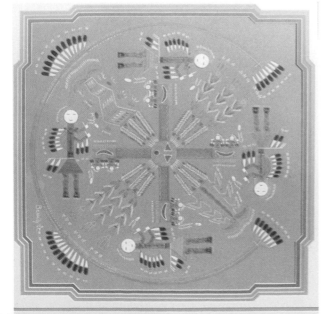

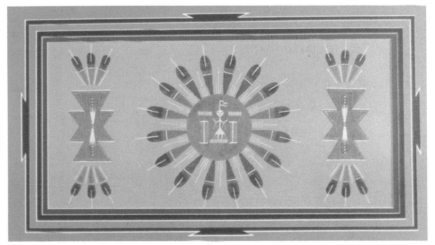

Phil Benally. "Sun and Eagle with Bar," traditional, 8″ x 16″. *Courtesy of Foutz Trading Company, Shiprock, NM.*

John Benally, Sr., 1989. "Whirling Log," traditional, 18″ x 18″. *Courtesy of Foutz Trading Company, Shiprock, NM.*

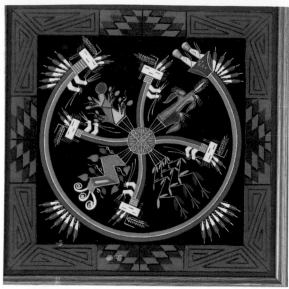

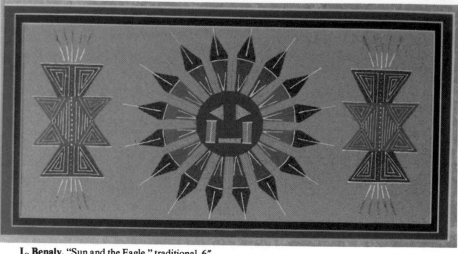

T. Benally. "Four Seasons," traditional. *Courtesy of Foutz Trading Company, Shiprock, NM.*

L. Benaly. "Sun and the Eagle," traditional, 6″ x 12″. *Courtesy of Foutz Trading Company, Shiprock, NM.*

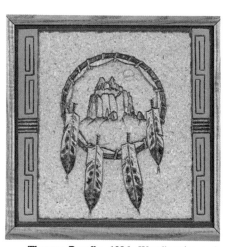

Thomas Benally, 1986. Woodburning and sandpainting of Shiprock, 9″ x 9″. *Courtesy of Foutz Trading Company, Shiprock, NM.*

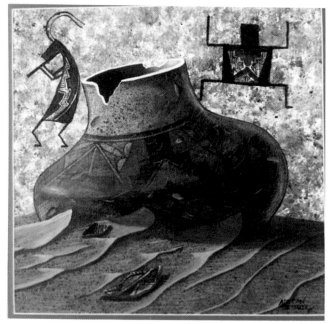

Adrian Bitsuie. Acrylic on sand, 12″ x 12″. Adrian Bitsuie is Marie Bitsuie's nephew. *Courtesy of Arroyo Trading Co., Farmington, NM.*

Adrian Bitsuie. Acrylic on sand, 12″ x 12″. *Courtesy of Arroyo Trading Co., Farmington, NM.*

V. Benally. "Sun," traditional, 12″ x 12″. *Courtesy of Foutz Trading Company, Shiprock, NM.*

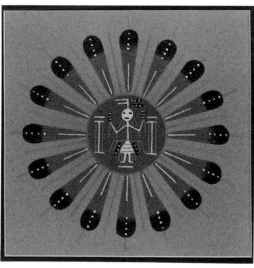

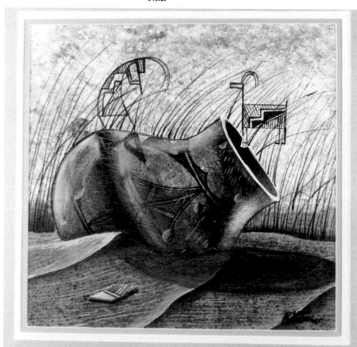

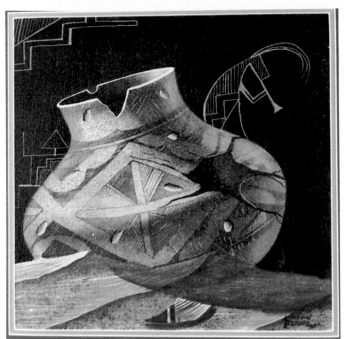

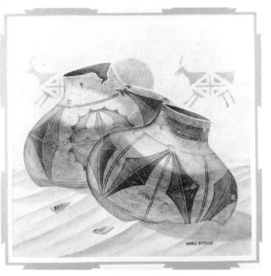

Marie Bitsuie. Acrylic on sand, 18″ x 18″. Marie Bitsuie is the widow of Bobby Johnson. *Courtesy of Arroyo Trading Co., Farmington, NM.*

Adrian Bitsuie, 1990. Acrylic on sand, 12″ x 12″. *Courtesy of Arroyo Trading Co., Farmington, NM.*

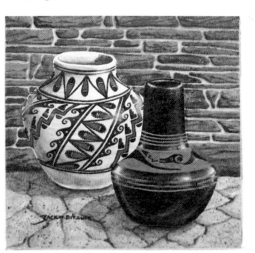

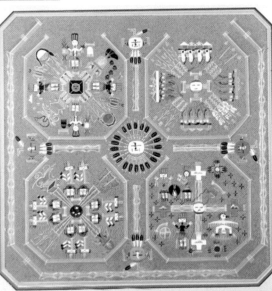

Thomas and Cora Bryant, Sheep Springs. Traditional sandpainting with four designs, 18″ x 18″. Clockwise from top right: "Buffalo People;" "Coyote Stealing Fire; "Rainbow People; and "Home of the Bear." *Courtesy of Arroyo Trading Co., Farmington, NM.*

Jack W. Bitsuie. Sand and acrylic, 6″ x 6″. *Courtesy of Foutz Trading Company, Shiprock, NM.*

Jack W. Bitsuie. "Kachina," sand art, 10″ x 8″. *Courtesy of Foutz Trading Company, Shiprock, NM.*

Thomas and Cora Bryant. Traditional sandpainting, 18″ x 18″. *Courtesy of Arroyo Trading Co., Farmington, NM.*

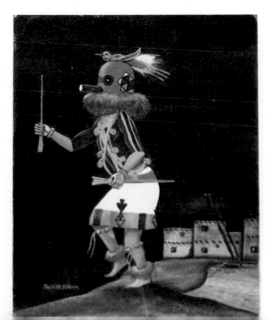

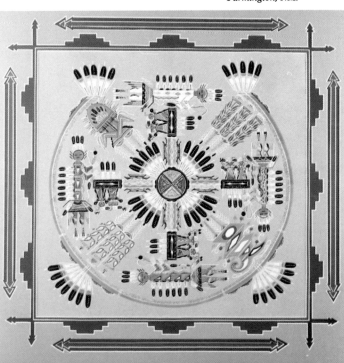

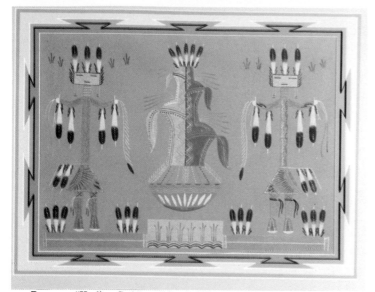

Byerson. "Healing God," traditional, 12" x 16". *Courtesy of Foutz Trading Company, Shiprock, NM.*

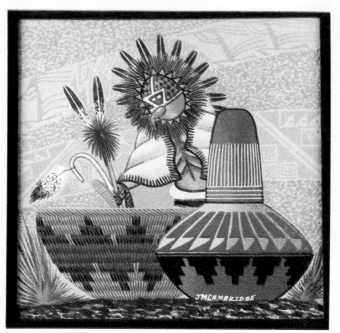

J.M. Cambridge. "Ahöla," sand art, 12" x 12". Ahöla is an important chief Kachina for the first and second mesas, as he opens the Powamu ceremony with a kiva performance on the first night. The performance seems to involve mimetic magic to slow the passage of the sun. At a shrine in the "Gap" of first mesa the next day, an additional rite is performed as the sun rises. At daybreak Ahul (Ahöla) and the Powamu chief deposit pahos (prayer feathers) at Kachina Spring, for he is the ancient one of the Kachina clan. *Courtesy of Shiprock Trading Company, Shiprock, NM.*

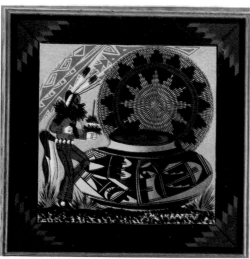

J.M. Cambridge. "Kachina," sand art. *Courtesy of Foutz Trading Company, Shiprock, NM.*

J.M. Cambridge, 1989. "Sunface Dancer," sand art, 16" x 16". *Courtesy of Foutz Trading Company, Shiprock, NM.*

J.M. Cambridge. "Deer kachina," sand art, 20" x 16". *Courtesy of Foutz Trading Company, Shiprock, NM.*

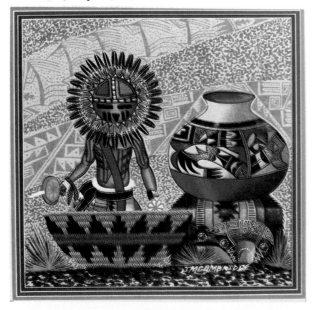

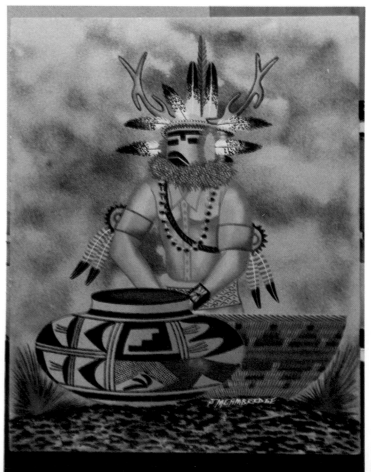

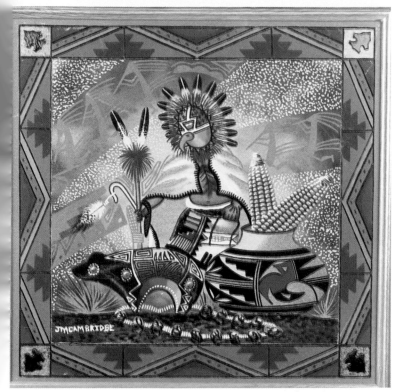

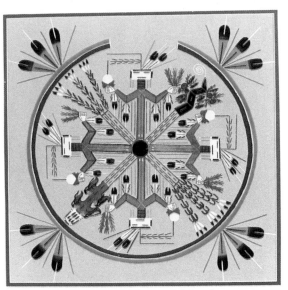

Nelson Cambridge. "Whirling Log Rainbow," traditional, 16″ x 16″. *Courtesy of Foutz Trading Company, Shiprock, NM.*

J.M. Cambridge. "Bear Kachina and Bowl," sand art, 18″ x 18″. *Courtesy of Foutz Trading Company, Shiprock, NM.*

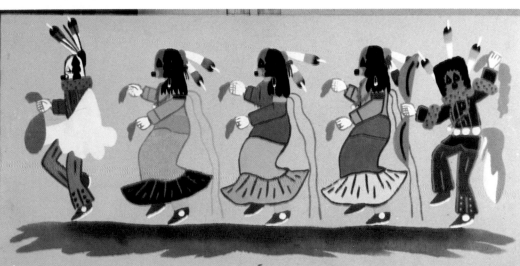

Nelson Cambridge. "Yei Be Chai," 12″ x 24″. "Yei be chai only perform in winter when all the snakes are asleep and there is no danger of lightning. They perform for nine days." *Courtesy of Foutz Trading Company, Shiprock, NM.*

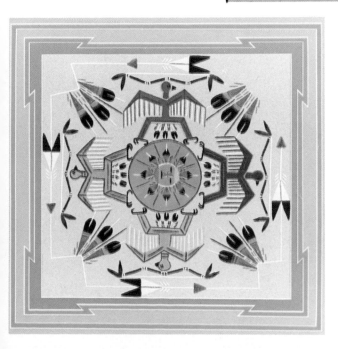

N. Cambridge, Two Grey Hills, Tohatchi, NM. Traditional sandpainting, 13″ x 13″. *Courtesy of Foutz Trading Company, Shiprock, NM.*

21

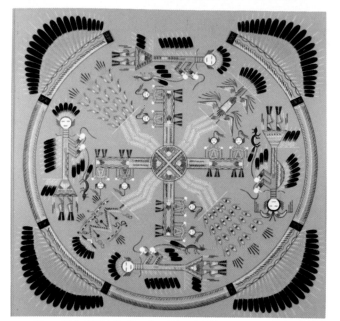

Terry Clah. "Whirling Log," traditional, 24" x 24". *Courtesy of Arroyo Trading Co., Farmington, NM.*

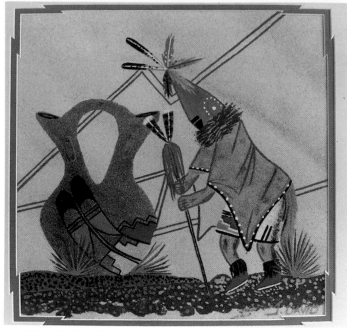

J. David. "Kachina and Pot," 12" x 12". *Courtesy of Arroyo Trading Co., Farmington, NM.*

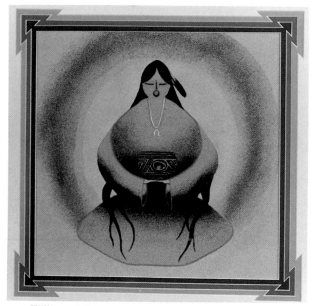

William Collins IV (Greyeyes). "Brown Woman," 13" x 13". *Courtesy of Foutz Trading Company, Shiprock, NM.*

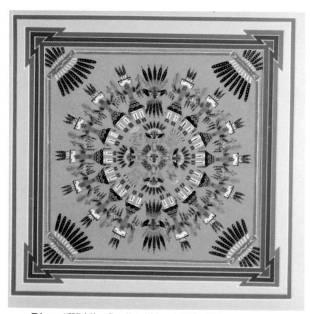

Diane. "Whirling Sun," traditional, 12" x 12". *Courtesy of Foutz Trading Company, Shiprock, NM.*

Grace Dick. "Four Seasons," Grace Dick is the brother of J.M. Cambridge and the wife of Keith Silversmith. *Courtesy of Foutz Trading Company, Shiprock, NM.*

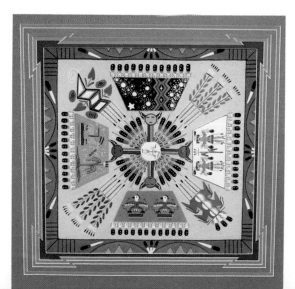

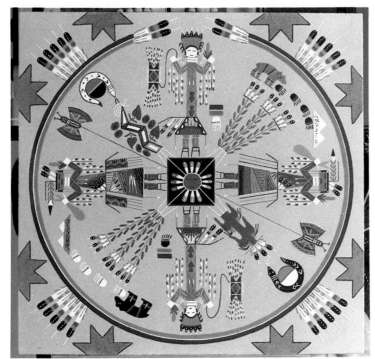

Gracie Dick. "Home of the Bear and Snake,"
traditional, 24″ x 24″. *Courtesy of Arroyo
Trading Co., Farmington, NM.*

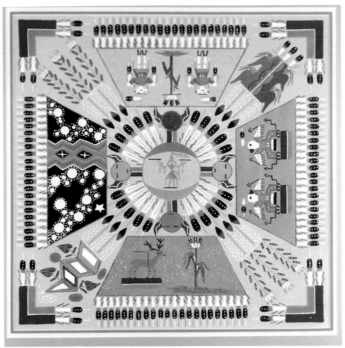

Gracie Dick and Keith Silversmith. "Storm
Figure," traditional, 18″ x 18″. *Courtesy of
Arroyo Trading Co., Farmington, NM.*

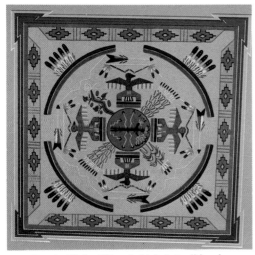

Gracie Dick. "Thunderbirds," traditional.
*Courtesy of Foutz Trading Company, Shiprock,
NM.*

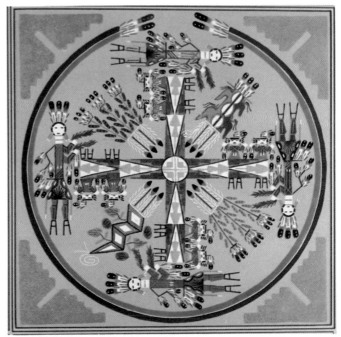

Gracie Dick and Keith Silversmith. "Whirling
Log," traditional, 18″ x 18″. *Courtesy of
Arroyo Trading Co., Farmington, NM.*

23

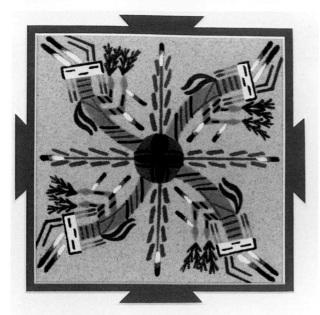

Enrico. Traditional sandpainting, 6″ x 6″. *Courtesy of Foutz Trading Company, Shiprock, NM.*

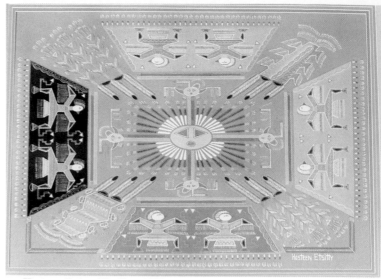

Hosteen Etsitty Binullea, 1989. "Storm-n-Lightning," traditional, 27″ x 20″. *Courtesy of Foutz Trading Company, Shiprock, NM.*

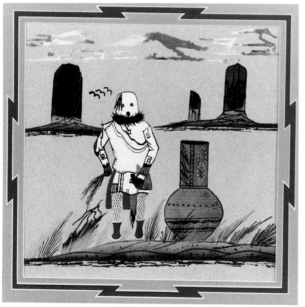

Bronson Enrico. "Kachina," 12″ x 12″. *Courtesy of Foutz Trading Company, Shiprock, NM.*

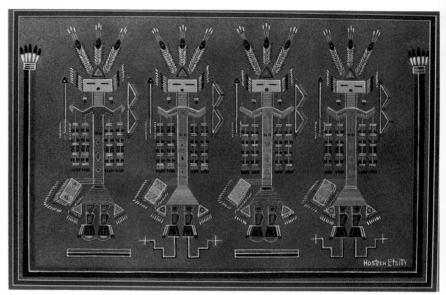

Hosteen Etsitty Binullea, 1989. "Arrow Flint People," traditional, 13″ x 20″. The figures represent Holy Man, Holy Woman, Holy Boy, and Holy Girl. *Courtesy of Foutz Trading Company, Shiprock, NM.*

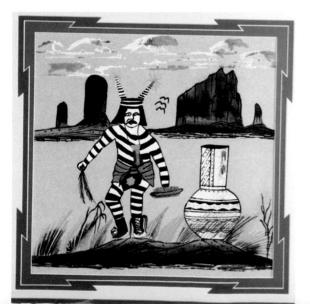

Bronson Enrico. "Koyala," 12″ x 12″. *Courtesy of Foutz Trading Company, Shiprock, NM.*

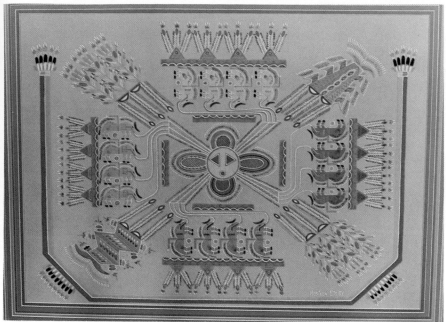

Hosteen Etsitty Binullea, 1989 . "Buffalo People in Fair Sectors," traditional, 20″ x 27″. *Courtesy of Foutz Trading Company, Shiprock, NM.*

Hosteen Etsitty Binullea, 1989. "Whirling Logs," traditional, 18″ x 18″. *Courtesy of Foutz Trading Company, Shiprock, NM.*

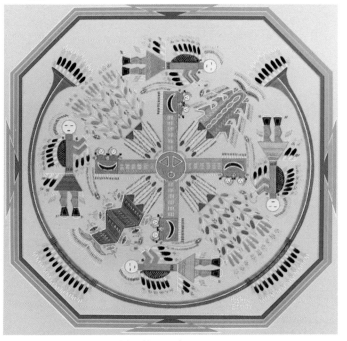

Hosteen Etsitty Binullea. "Storm-n-Lightning," traditional, 13″ x 13″. *Courtesy of Foutz Trading Company, Shiprock, NM.*

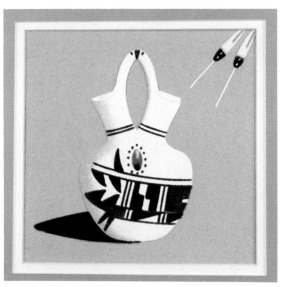

Harrison Frank. Sand art, 8″ x 8″. *Courtesy of Shiprock Trading Company, Shiprock, NM.*

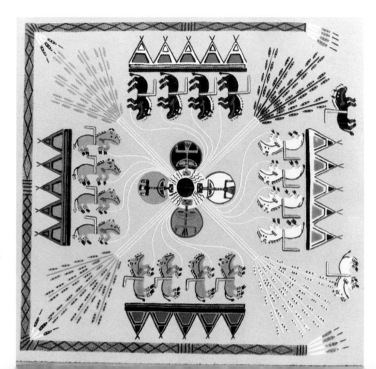

Larry Harrison. "The Home of the Buffalo People," traditional, 18″ x 18″. *Courtesy of Arroyo Trading Co., Farmington, NM.*

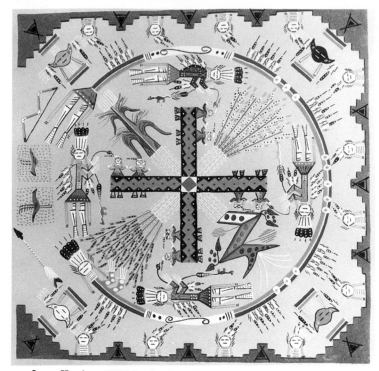

Larry Harrison. "Whirling Log," traditional, 24″ x 24″. *Courtesy of Arroyo Trading Co., Farmington, NM.*

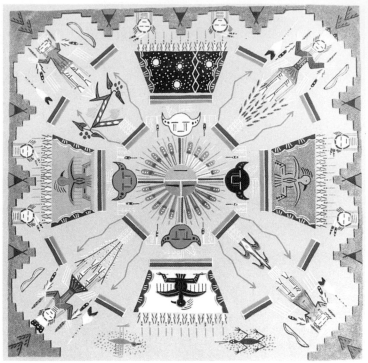

Larry Harrison. "Storm Figure," traditional, 24″ x 24″. *Courtesy of Arroyo Trading Co., Farmington, NM.*

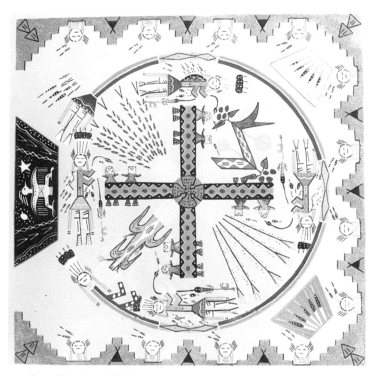

Larry Harrison. "Whirling Log," traditional, 24″ x 24″. *Courtesy of Arroyo Trading Co., Farmington, NM.*

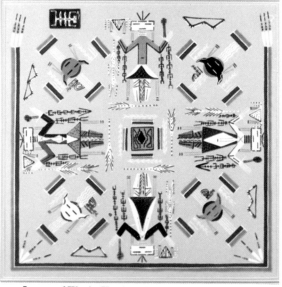

Larry and Wanita Harrison. Traditional sand-painting, 18″ x 18″. *Courtesy of Arroyo Trading Co., Farmington, NM.*

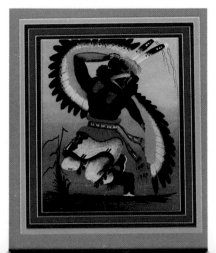

Harvey. "Dancing Kachina". *Courtesy of Foutz Trading Company, Shiprock, NM.*

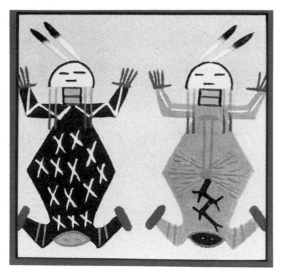

Fred Hayes. "Father Sky and Mother Earth," traditional, 6″ x 6″. *Courtesy of Foutz Trading Company, Shiprock, NM.*

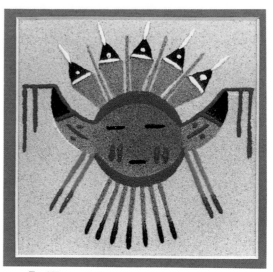

Fred Heyer. "Buffalo Horn Mask," traditional, 4″ x 4″. *Courtesy of Foutz Trading Company, Shiprock. NM.*

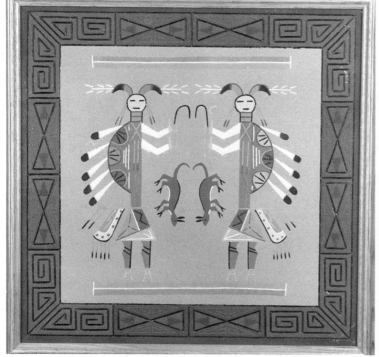

Fred Hayes. "Hunch Back Yei," traditional, 16″ x 16″. B'Ganoskiddy is known in English by a variety of names: Humpback yei, Navajo god of plenty or of harvest, and camel god. In his hands he holds the strings to a medicine bag in the shape of a weasel. *Courtesy of Foutz Trading Company, Shiprock, NM.*

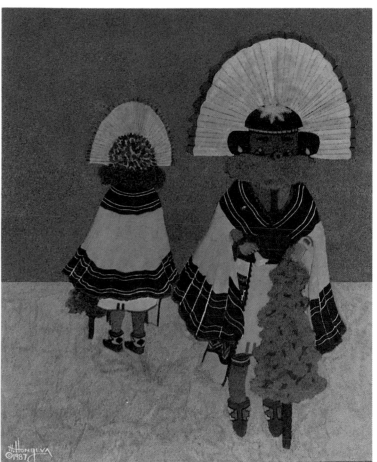

H. Hongeva, 1987. "Kachinas," 20″ x 24″. *Courtesy of Turquoise Lady, Albuquerque, NM.*

27

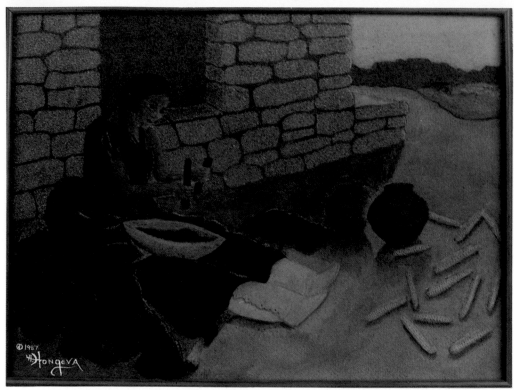

H. Hongeva, 1987. "Seated Woman," 12″ x 16″. *Courtesy of Turquoise Lady, Albuquerque, NM.*

D. Hosteen. Sand art, 16″ x 20″. *Courtesy of Foutz Trading Company, Shiprock, NM.*

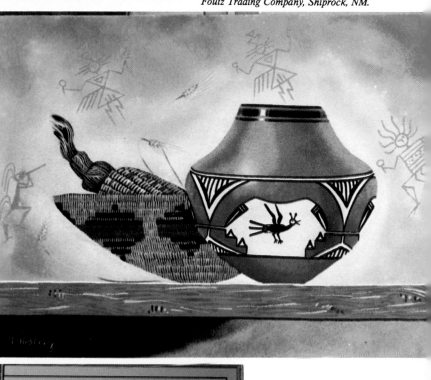

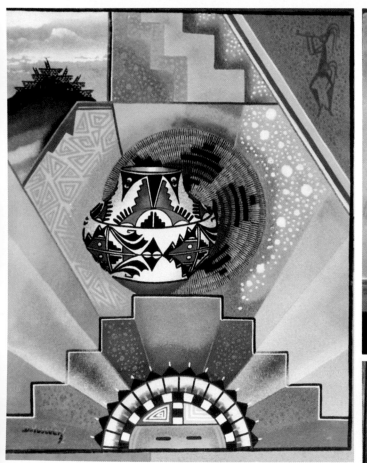

D. Hosteen. Sand art, 20″ x 16″. *Courtesy of Foutz Trading Company, Shiprock, NM.*

Dan Hosteen. "Whirling Logs and Humpback Yei". *Courtesy of Foutz Trading Company, Shiprock, NM.*

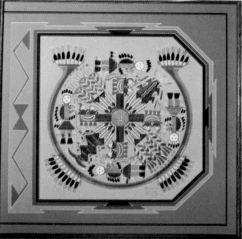

28

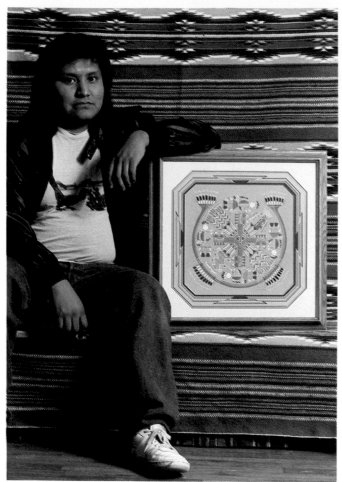

Dan Hosteen. The artist with "Whirling Logs". *Courtesy of Foutz Trading Company, Shiprock, NM.*

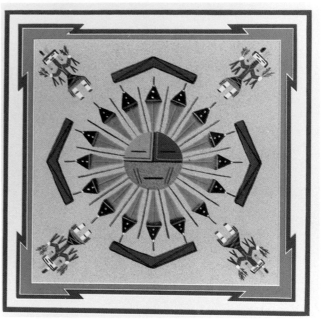

A. J. "Sun and Eagle, Female Yei," traditional, 13″ x 13″. *Courtesy of Foutz Trading Company, Shiprock, NM.*

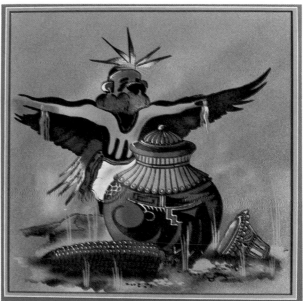

James. Sand art, 16″ x 16″. *Courtesy of Foutz Trading Company, Shiprock, NM.*

Eugene Baatsoslanii Joe, 1976. Sand art, 24″ x 12″. *Courtesy of Shiprock Trading Company, Shiprock, NM.*

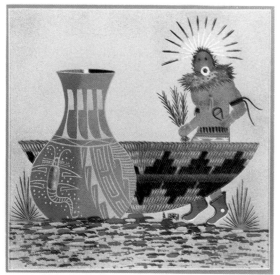

A. Iargo (?). Sand art, 12″ x 12″. *Courtesy of Foutz Trading Company, Shiprock, NM.*

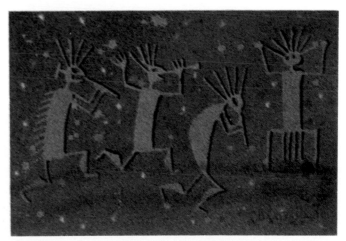

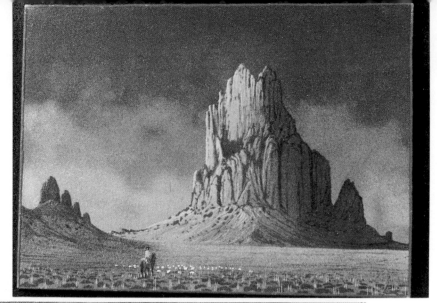

Eugene Baatsoslanii Joe, 1975. Sand art, 18″ x 24″. *Courtesy of Shiprock Trading Company, Shiprock, NM.*

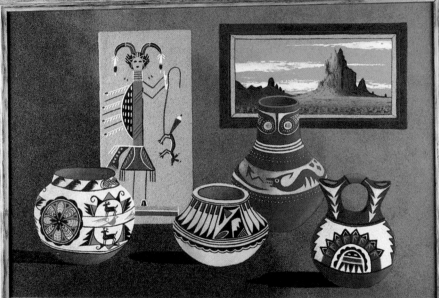

Eugene Baatsoslanii Joe, 1974. Sand art, 22″ x 32″. *Courtesy of Shiprock Trading Company, Shiprock, NM.*

Eugene Baatsoslanii Joe, 1974. Sand art, 16″ x 24″. *Courtesy of Shiprock Trading Company, Shiprock, NM.*

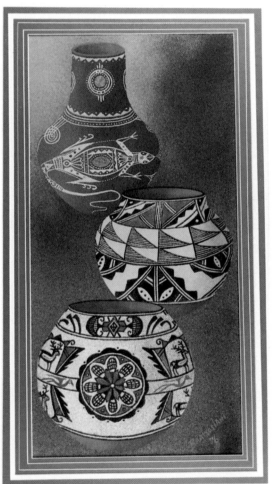

Eugene Baatsoslanii Joe. Traditional sand-painting . *Courtesy of Foutz Trading Company, Shiprock, NM.*

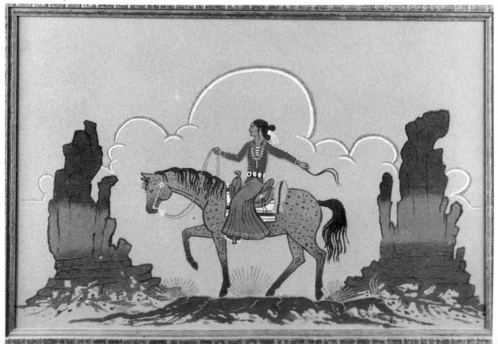

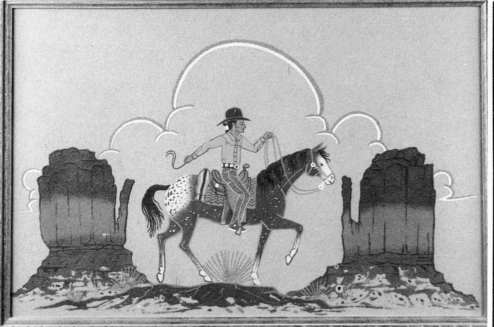

Eugene Baatsoslanii Joe, 1974. Sand art, 16″ x 24″. *Courtesy of Shiprock Trading Company, Shiprock, NM.*

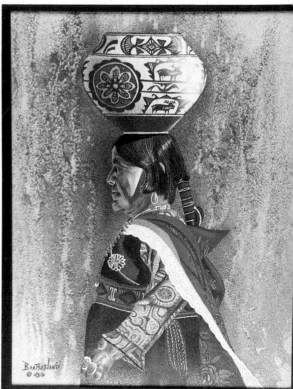

Eugene Baatsoslanii Joe, 1981. "Zuni Old Maiden," sand art, 24″ x 18″. *Courtesy of Shiprock Trading Company, Shiprock, NM.*

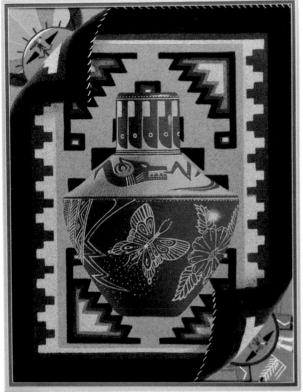

Eugene Baatsoslanii Joe, 1977. A pot with rising and setting suns in corners and applied turquoise on the butterfly, sand art, 24″ x 18″. *Courtesy of Shiprock Trading Company, Shiprock, NM.*

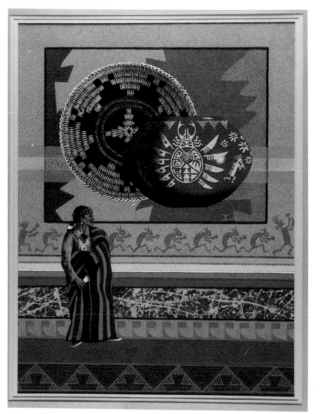

Eugene Baatsoslanii Joe. Sand art, 24″ x 18″. *Courtesy of Shiprock Trading Company, Shiprock, NM.*

Eugene Baatsoslanii Joe. Sandpainted deskset, mixed media, 8″ x 13″ x 7″. *Courtesy of Shiprock Trading Company, Shiprock, NM.*

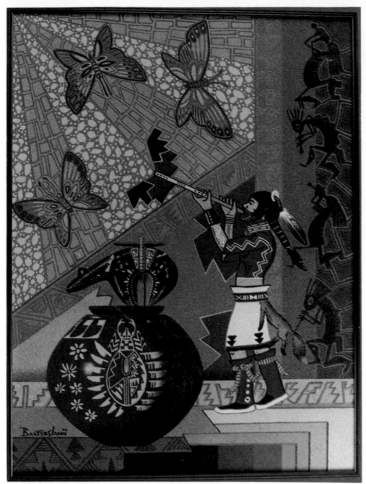

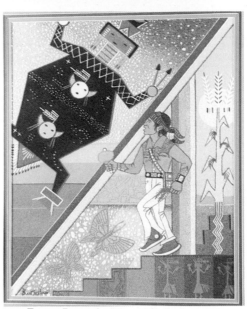

Eugene Baatsoslanii Joe, 1985. Sand art, 20″ x 16″. *Courtesy of Shiprock Trading Company, Shiprock, NM.*

Eugene Baatsoslanii Joe. Sand art, 24″ x 18″. *Courtesy of Turquoise Lady, Albuquerque, NM.*

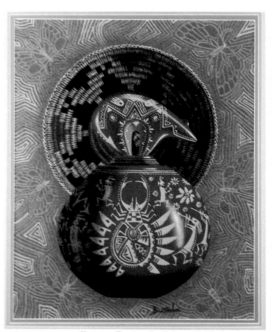

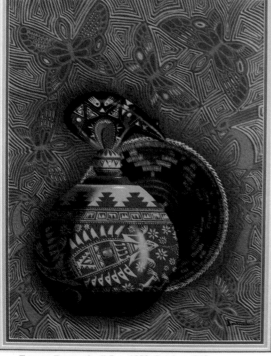

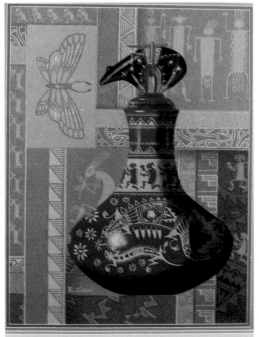

Eugene Baatsoslanii Joe, 1989. Sand art, 24″ x 18″. *Courtesy of Foutz Trading Company, Shiprock, NM.*

Eugene Baatsoslanii Joe, 1989. Sand art, 24″ x 18″. *Courtesy of Foutz Trading Company, Shiprock, NM.*

Eugene Baatsoslanii Joe. Sand art, 20″ x 16″. *Courtesy of Arroyo Trading Co., Farmington, NM.*

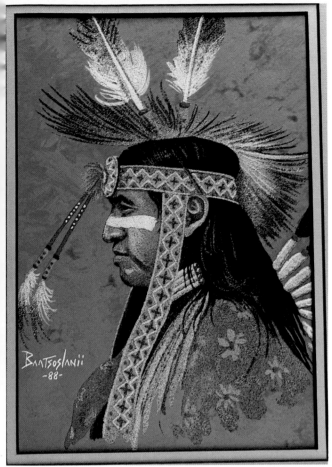

Eugene Baatsoslanii Joe, 1988. "Waiting for His Beat," oil and sand on masonite, 11" x 8". *Courtesy of Shiprock Trading Company, Shiprock, NM.*

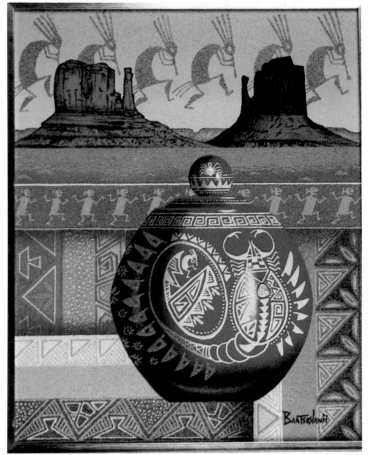

Eugene Baatsoslanii Joe, 1989. Pot with applied turquoise stone, sand art, 24" x 12". *Courtesy of Shiprock Trading Company, Shiprock, NM.*

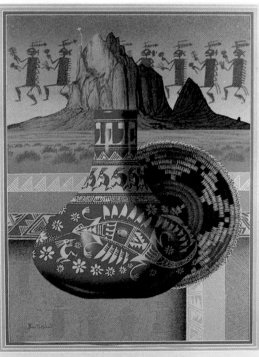

Eugene Baatsoslanii Joe, 1989. Sand art, 24" x 18". *Courtesy of Foutz Trading Company, Shiprock, NM.*

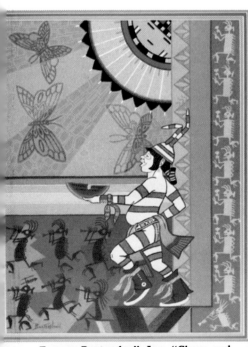

Eugene Baatsoslanii Joe. "Clown and Watermelon," sand art, 24"x18". *Courtesy of Arroyo Trading Co., Farmington, NM.*

Eugene Baatsoslanii Joe. Sandpainted souvenirs, mixed media, 6" x 9" x 3". *Courtesy of Shiprock Trading Company, Shiprock, NM.*

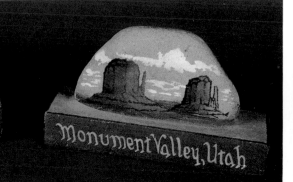

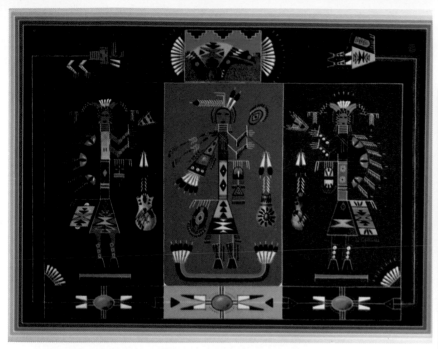

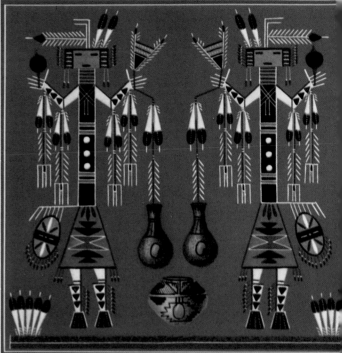

Esther and George "Atsa Yashi" Joe, 1989.
"Humpback Yei," traditional, 18" x 24".
Courtesy of Foutz Trading Company, Shiprock, NM.

Esther "Atsa Yashi" Watchman Joe. "Yei Be Chai," 12" x 12". *Courtesy of Foutz Trading Company, Shiprock, NM.*

Esther "Atsa Yashi" Watchman Joe.
Traditional sandpainting, 18" x 18". *Courtesy of Foutz Trading Company, Shiprock, NM.*

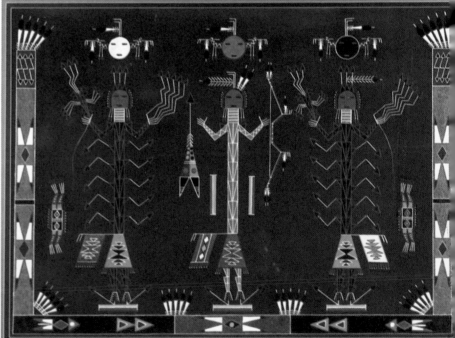

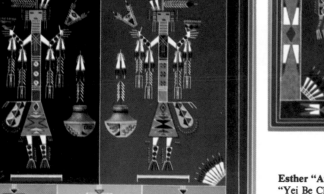

George Joe, 1985. "Lightning People," traditional, 18" x 24". *Courtesy of Shiprock Trading Company, Shiprock, NM.*

Esther "Atsa Yashi" Watchman Joe, 1990.
"Yei Be Chai," 18" x 18". *Courtesy of Foutz Trading Company, Shiprock, NM.*

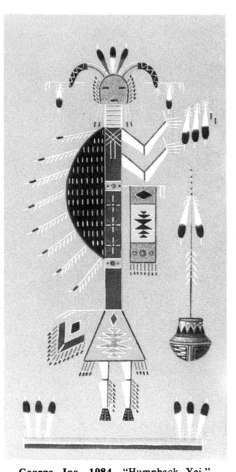

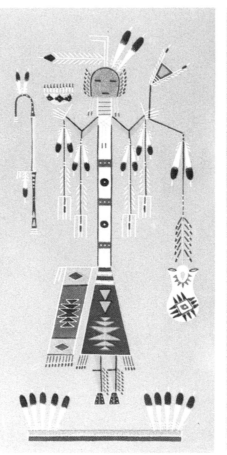

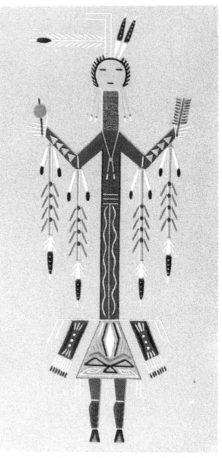

George Joe, 1984. "Humback Yei," traditional, 18″ x 9″. *Courtesy of Shiprock Trading Company, Shiprock, NM.*

George "Atsa Yashi" Joe. "Yei Be Chai," traditional, 18″ x 9″. *Courtesy of Shiprock Trading Company, Shiprock, NM.*

George "Atsa Yashi" Joe. "Yei Be Chai," traditional, 18″ x 9″. *Courtesy of Shiprock Trading Company, Shiprock, NM.*

George Joe, 1984. "Yei Be Chai," traditional, 18″ x 9″. *Courtesy of Shiprock Trading Company, Shiprock, NM.*

George "Atsa Yashi" Joe. "The Gods," traditional, 13″ x 13″. *Courtesy of Shiprock Trading Company, Shiprock, NM.*

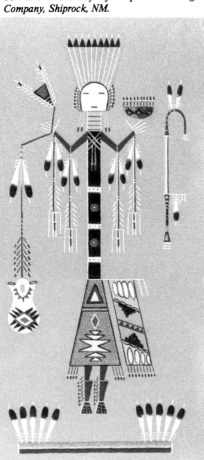

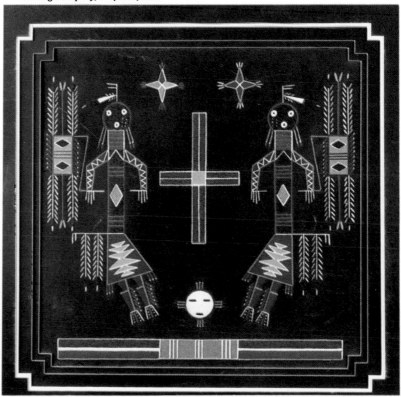

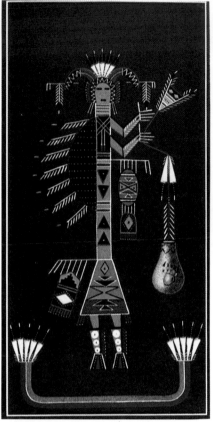

George "Atsa Yashi" Joe. "Humpback Yei," traditional. *Courtesy of Shiprock Trading Company, Shiprock, NM.*

James C. Joe. "Sun Set Yei," traditional, 18″ x 8″. *Courtesy of Shiprock Trading Company, Shiprock, NM.*

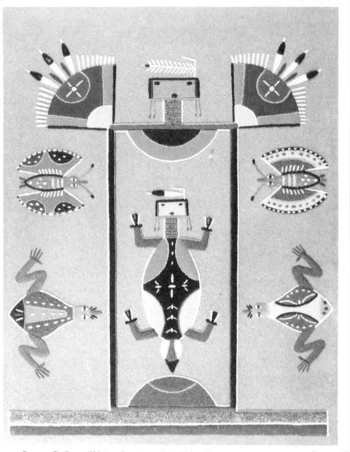

James C. Joe. "Water Creatures," traditional, 18″ x 14″. Butterflies and frogs border a water creature. The rectangle shape represents a home for all water creatures. *Courtesy of Shiprock Trading Company, Shiprock, NM.*

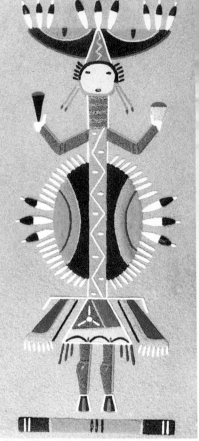

James C. Joe. "Cloud People," traditional, 18″ x 9″. *Courtesy of Shiprock Trading Company, Shiprock, NM.*

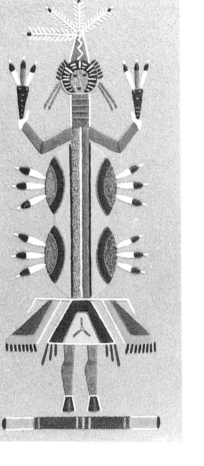

James C. Joe. "Corn," traditional, 16″ x 20″. In this ceremonial sandpainting the planting of corn is celebrated with the rain people on the sides and corn in the middle. *Courtesy of Shiprock Trading Company, Shiprock, NM.*

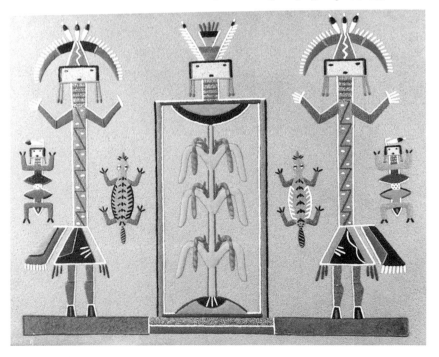

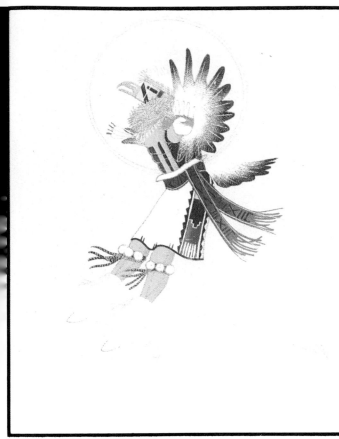

Oreland C. Joe, Shiprock, 1983. "Eagle Kachina," 18″ x 14″. *Courtesy of Shiprock Trading Company, Shiprock, NM.*

George John, Farmington. Sand art, 24″ x 18″. George is married to Margaret John *Courtesy of Foutz Trading Company, Shiprock, NM.*

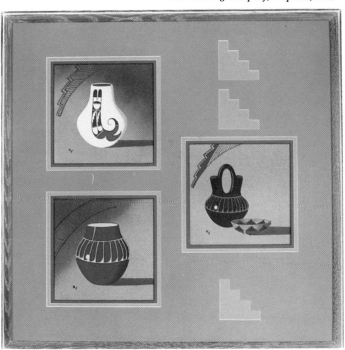

George John. Sand art, 30″ x 24″. *Courtesy of Foutz Trading Company, Shiprock, NM.*

Margaret John, Farmington. Three sand-paintings of pots. *Courtesy of Bing Crosby's, Albuquerque.*

Margaret John. Two sandpaintings. *Courtesy of Foutz Trading Company, Shiprock, NM.*

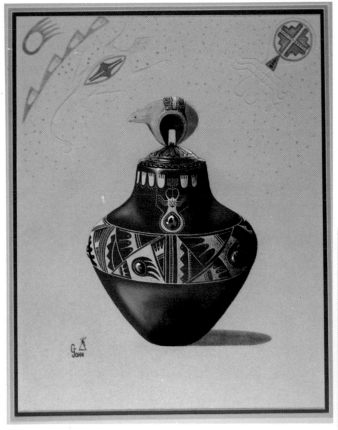

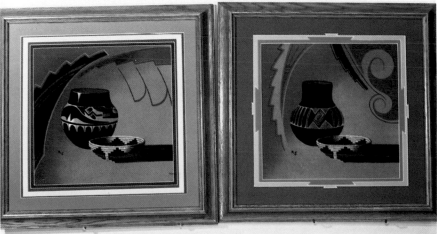

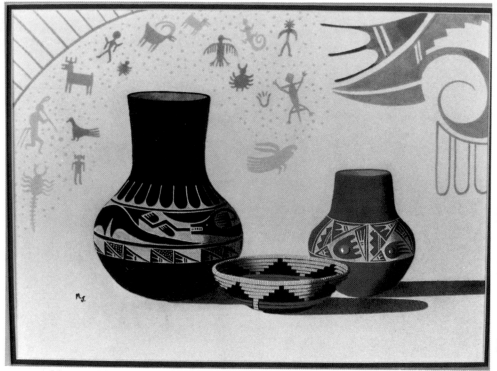

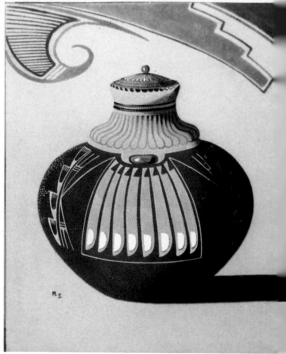

Margaret John. Two pots and a basket, 24″ x 18″. *Courtesy of Foutz Trading Company, Shiprock, NM.*

Margaret John. Sand art, 16″ x 29″. *Courtesy of Arroyo Trading Co., Farmington, NM.*

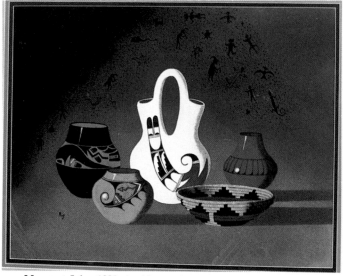

Margaret John, 1989. A white marriage pot and three others, with a basket, 16″ x 20″. *Courtesy of Foutz Trading Company, Shiprock, NM.*

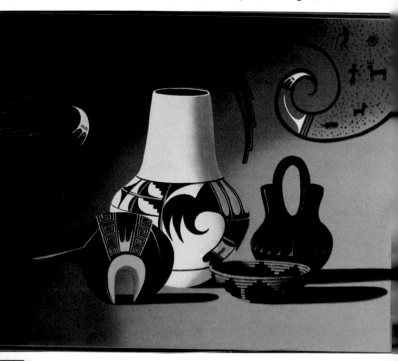

Margaret John. Sand art . *Courtesy of Foutz Trading Company, Shiprock, NM.*

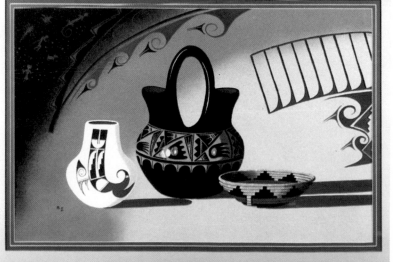

Margaret John. Sand art, 20″ x 24″. *Courtesy of Foutz Trading Company, Shiprock, NM.*

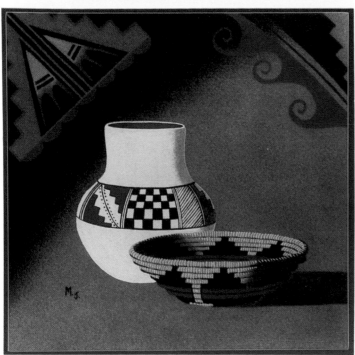

Margaret John. Sand art. *Courtesy of Bing Crosby's, Albuquerque.*

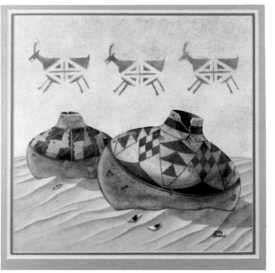

Larry Johnson. Acrylic on sand, 18″ x 18″. This uncle of Adrian Bitsuie learned sand painting from Bobby Johnson. *Courtesy of Arroyo Trading Co., Farmington, NM.*

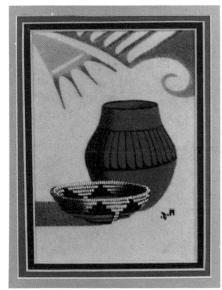

Margaret John. "Pot and Basket," 7″ x 5″. *Courtesy of Foutz Trading Company, Shiprock, NM.*

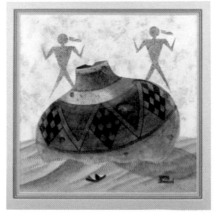

Larry Johnson. Acrylic on sand, 12″ x 12″. *Courtesy of Arroyo Trading Co., Farmington, NM.*

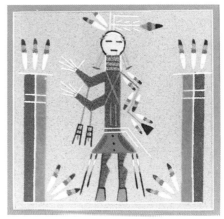

Lester Johnson. "Coyote God," traditional, 6″ x 6″. *Courtesy of Foutz Trading Company, Shiprock, NM.*

Lester Johnson. "Chant People with Corn," traditional, 12″ x 12″. *Courtesy of Foutz Trading Company, Shiprock, NM.*

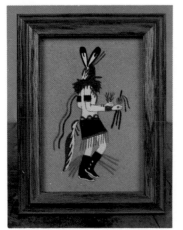

L. Johnson. Sand art, Yei Be Chai . *Courtesy of The Indian Post, Allentown, PA.*

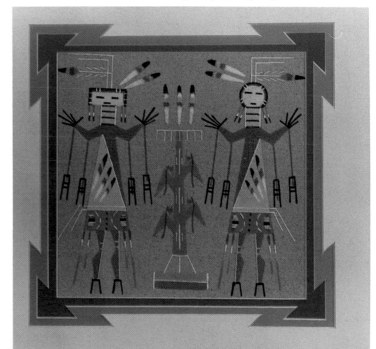

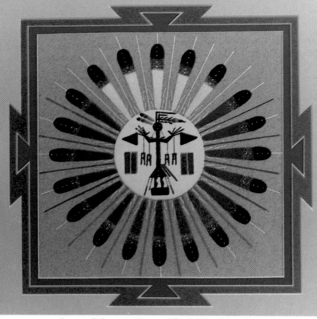

Lester Johnson. "Sun and Eagle," traditional, 12″ x 12″. *Courtesy of Foutz Trading Company, Shiprock, NM.*

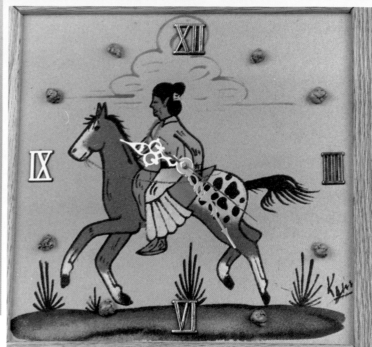

Keim. Sandpainted clock, 11″ x 11″. Made for the tourist trade. *Courtesy of Indian Trader West, Santa Fe, NM.*

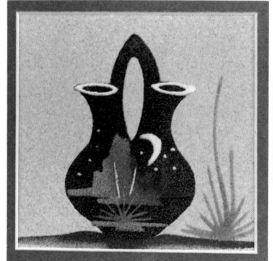

R. Johnson. Sand art, 4″ x 4″. *Courtesy of Foutz Trading Company, Shiprock, NM.*

R. Johnson. "Four Sacred Plants," traditional theme, 4″ x 4″. *Courtesy of Foutz Trading Company, Shiprock, NM.*

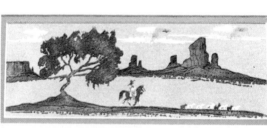

Anthony Lee (Anthony Tsosie?). "Landscape with Rider". *Courtesy of Foutz Trading Company, Shiprock, NM.*

Anthony Lee (Anthony Tsosie?), 1989. "Navajo Boy Sitting on Horse," 16″ x 16″. *Courtesy of Foutz Trading Company, Shiprock, NM.*

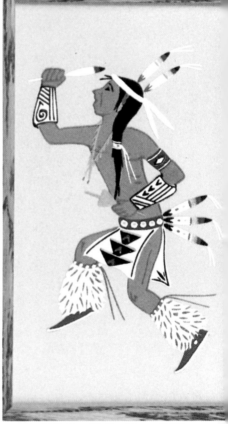

David V. Lee. "Indian Dancer," 12″ x 7″. *Courtesy of Shiprock Trading Company, Shiprock, NM.*

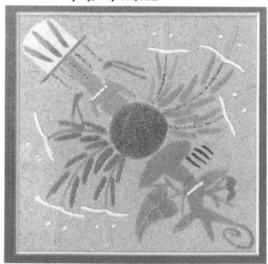

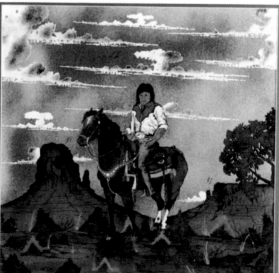

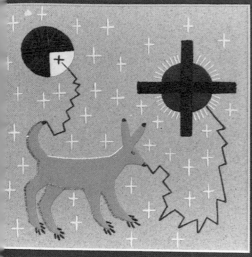

D.V. Lee, Sheepspring, NM. "Coyote Stealing Fire," traditional theme, 6″ x 6″. *Courtesy of Foutz Trading Company, Shiprock, NM.*

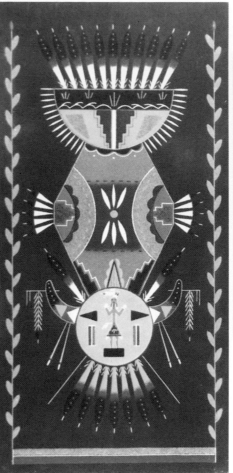

Judy and Nelson Lewis. "Sun Verse," traditional, 24″ x 12″. *Courtesy of Shiprock Trading Company, Shiprock, NM.*

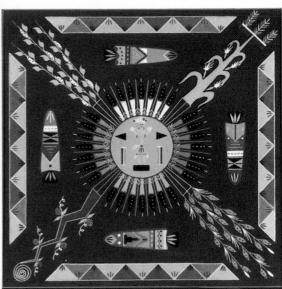

Nelson Lewis, Shiprock. "Sun and Eagle (The Beauty Way)," traditional, 18″ x 18″. *Courtesy of Shiprock Trading Company, Shiprock, NM.*

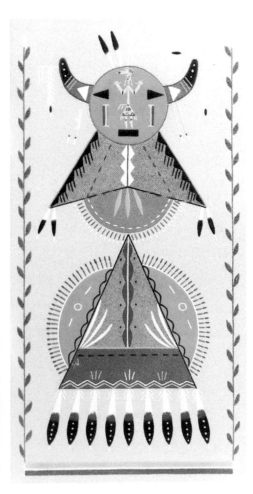

Judy and Nelson Lewis, Shiprock. "Sun Verse," traditional, 24″ x 12″. *Courtesy of Shiprock Trading Company, Shiprock, NM.*

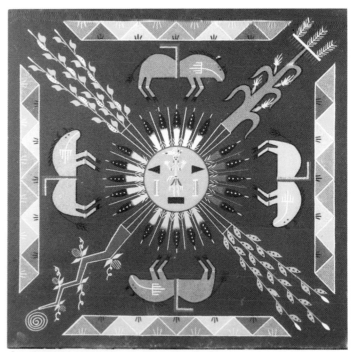

Nelson Lewis. "Sun and Eagle (The Beauty Way)," traditional, 18″ x 18″. *Courtesy of Shiprock Trading Company, Shiprock, NM.*

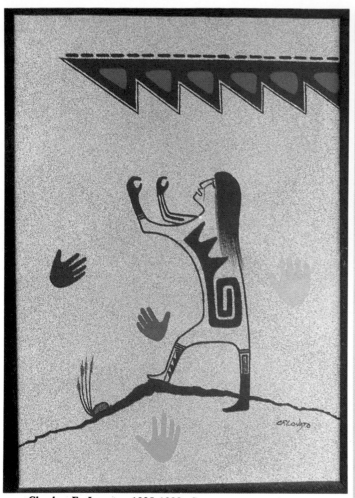

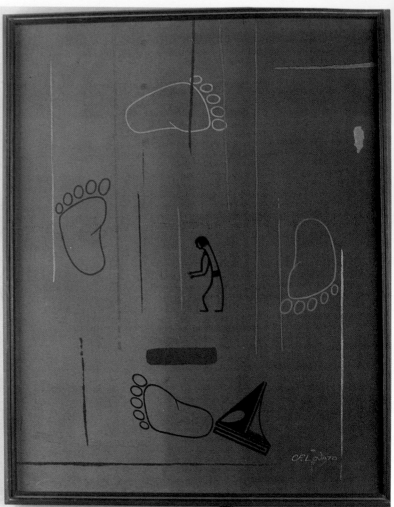

Charles F. Lovato, 1935-1988, Santa Domingo Pueblo. These three sandpaintings by Charles Lovato illustrate a poem:

Quiet intrusions enter into the twilight hours of my mind

While I in deep slumber cease to hear their footsteps.

These will be thoughts when I awaken

These intrusions will then guide this conscience of mine.

Charles F. Lovato.

Charles F. Lovato.

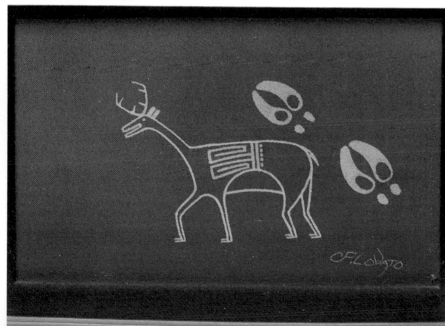

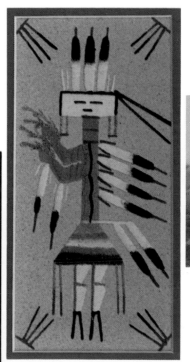

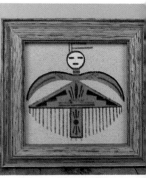

Rosie Manuelito. "Rain Bird," traditional. *Courtesy of The Indian Post, Allentown, PA.*

B.Z.M. "Yei," traditional, 4″ x 8″. *Courtesy of Foutz Trading Company, Shiprock, NM.*

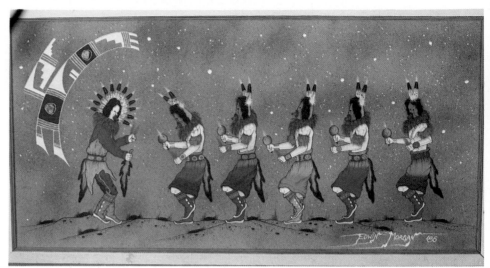

Edwin Morgan, 1986. Sand art. *Courtesy of Bing Crosby's, Albuquerque.*

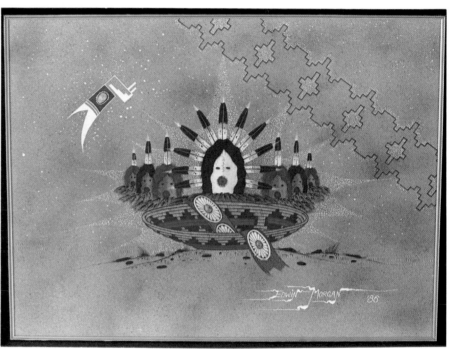

Edwin Morgan, 1986. Sand art. *Courtesy of Bing Crosby's, Albuquerque.*

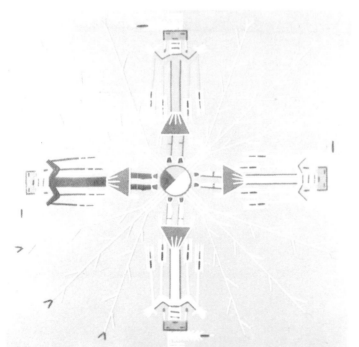

Matiney (?). "Portrait of an Indian," 20″ x 16″. *Courtesy of Arroyo Trading Co., Farmington, NM.*

Chee McDonald, Torreon, Ojo Encino, 1971. "Storm People," 24″ x 24″. The storm people of the Hail Chant stand four square on the rainbow bars facing the cardinal points. *Courtesy of Shiprock Trading Company, Shiprock, NM.*

43

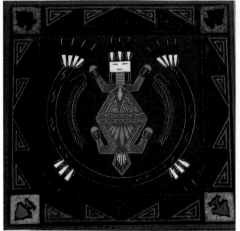

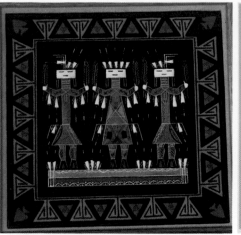

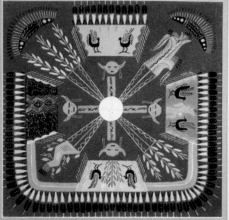

Myerson & T. Benally. "Water Creature," traditional. *Courtesy of Foutz Trading Company, Shiprock, NM.*

Myerson & T. Benally. Traditional sandpainting. *Courtesy of Foutz Trading Company, Shiprock, NM.*

Myerson, 1989. "Storm Figures," traditional, 12" x 12". *Courtesy of Foutz Trading Company, Shiprock, NM.*

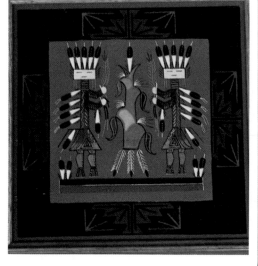

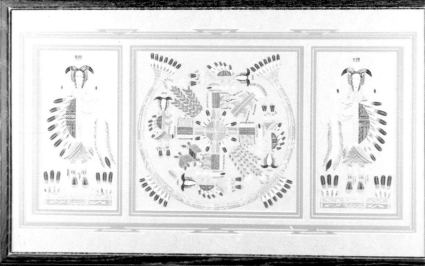

Myerson and T. Benally. "Two Yei and Corn," traditional. *Courtesy of Foutz Trading Company, Shiprock, NM.*

Myerson, 1990. A triptych of traditional sandpainting. Left to right: "Healing God," (12" x 6"); "Home of the Bears and Snakes," (12" x 12"); "Healing God," (12" x 6"). *Courtesy of Arroyo Trading Co., Farmington, NM.*

Myerson, 1990. A triptych of traditional sandpaintings. Left to right: "Humpback Yei," (12" x 6"); "Whirling Log," (12" x 12"); "Humpback Yei," (12" x 6"). *Courtesy of Arroyo Trading Co., Farmington, NM.*

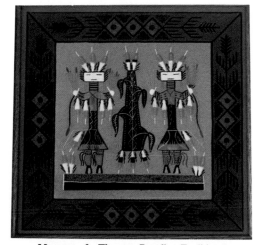

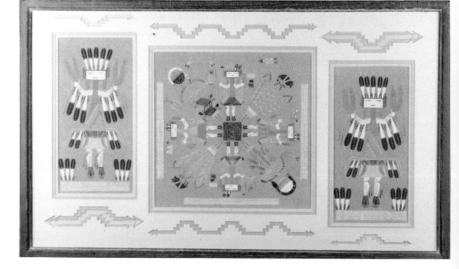

Myerson & Thomas Benally. Traditional sandpainting. *Courtesy of Foutz Trading Company, Shiprock, NM.*

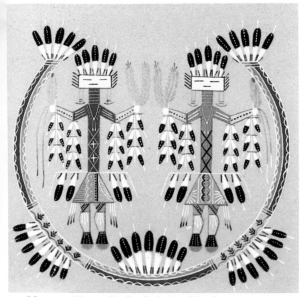

Myerson. "Female Healing Gods," traditional, 12″ x 12″. *Courtesy of Shiprock Trading Company, Shiprock, NM.*

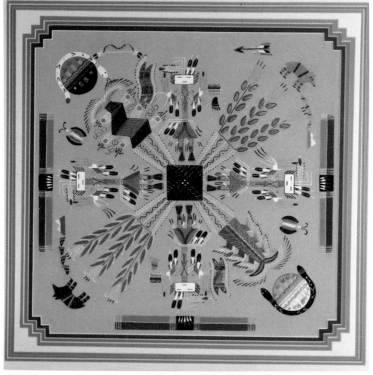

Myerson, 1989. "Home of the Bears and Snakes," traditional, 18″ x 18″. *Courtesy of Foutz Trading Company, Shiprock, NM.*

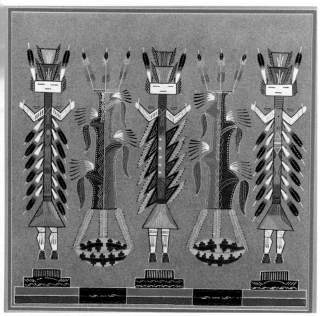

Myerson, 1989. "Healing Gods," traditional, 18″ x 18″. *Courtesy of Foutz Trading Company, Shiprock, NM.*

Myerson, 1988. "Storm Figures," traditional, 12″ x 12″. *Courtesy of Foutz Trading Company, Shiprock, NM.*

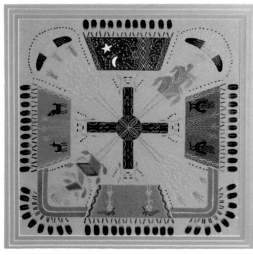

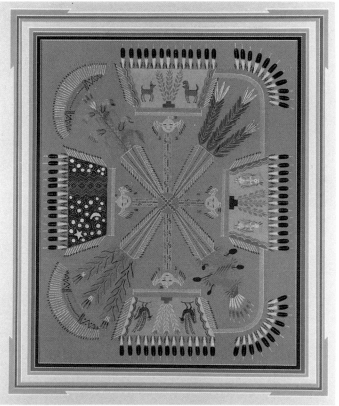

Myerson, 1988. "Storm Pattern," traditional, 20″ x 16″. *Courtesy of Foutz Trading Company, Shiprock, NM.*

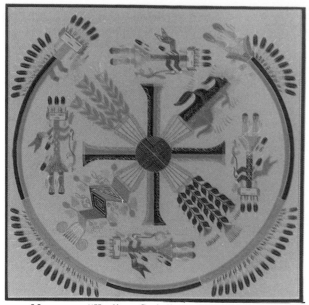

Myerson. "Healing Gods," traditional, 18″ x 18″. *Courtesy of Foutz Trading Company, Shiprock, NM.*

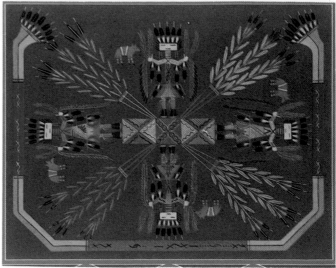

Myerson, 1988. Traditional sandpainting, 20″ x 16″. *Courtesy of Foutz Trading Company, Shiprock, NM.*

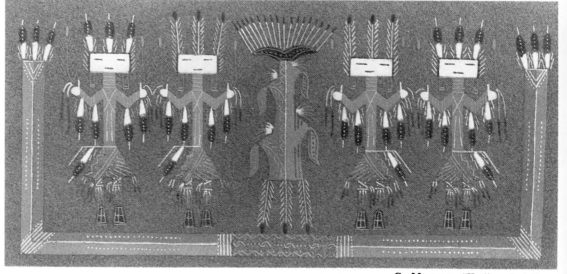

C. Myerson. "Healing Gods," traditional, 6″ x 12″. *Courtesy of Foutz Trading Company, Shiprock, NM.*

Myerson, 1989. "Storm Patterns," traditional, 18″ x18″. *Courtesy of Foutz Trading Company, Shiprock, NM.*

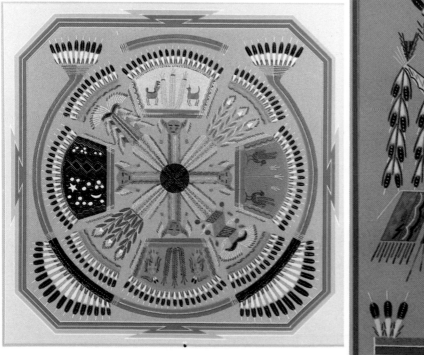

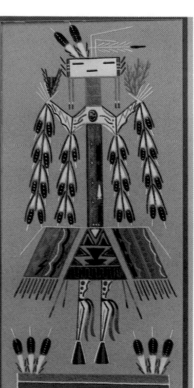

J. Myerson. "A ceremonial sandpainting for healing in many ways," traditional. *Courtesy of Bing Crosby's, Albuquerque.*

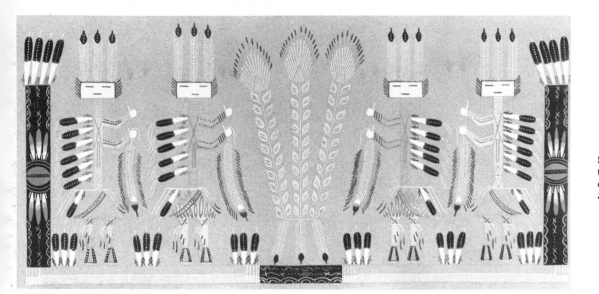

S. Myerson. "Healing Gods," traditional, 12″ x 24″. *Courtesy of Foutz Trading Company, Shiprock, NM.*

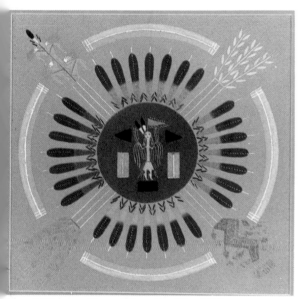

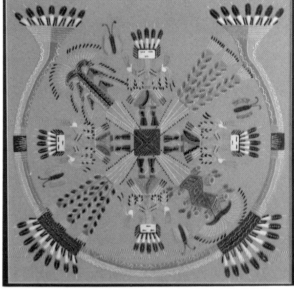

S. Myerson. "Sun and Plants," traditional, 12″ x 12″. *Courtesy of Foutz Trading Company, Shiprock, NM.*

S. Myerson. "Yei and Plant," traditional, 12″ x 12″. *Courtesy of Foutz Trading Company, Shiprock, NM.*

S. Myerson. "Healing God," traditional, 12″ x 16″. *Courtesy of Foutz Trading Company, Shiprock, NM.*

S. Myerson, 1989. "Creation Story," traditional, 12″ x 12″. *Courtesy of Foutz Trading Company, Shiprock, NM.*

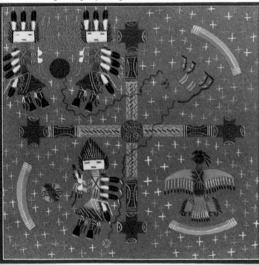

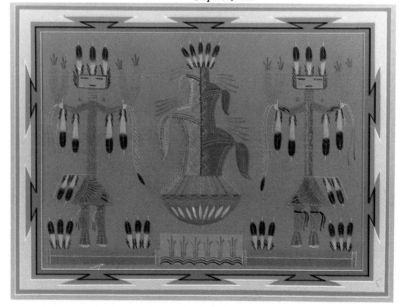

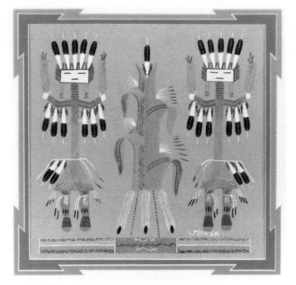

S. Myerson, 1989. "Navajo Healing God," traditional, 12″ x 12″. *Courtesy of Foutz Trading Company, Shiprock, NM.*

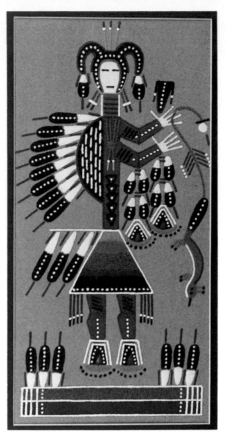

Wilfred Natsinni (Apache), 1987. "Humpback Yei," traditional, 12″ x 6″. *Courtesy of Foutz Trading Company, Shiprock, NM.*

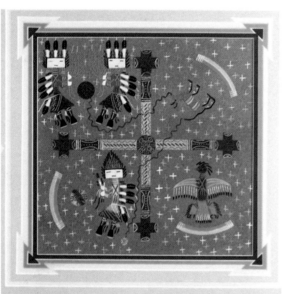

Sam Myerson. "Coyote Stealing Fire," traditional, 16″ x 16″. *Courtesy of Foutz Trading Company, Shiprock, NM.*

Wilfred Natsinneh (Natsinnie?), 1986. "Sun and Eagle and Female Yei," traditional, 12″ x 24″. *Courtesy of Shiprock Trading Company, Shiprock, NM.*

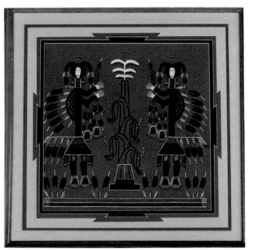

Wilfred Natsinnie. "Humpback Yei with Corn". *Courtesy of Foutz Trading Company, Shiprock, NM.*

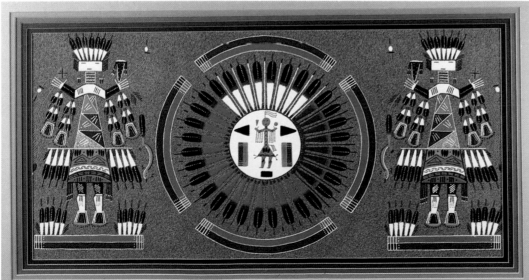

Nocki Nelson, Red Valley, AZ. Sandpainting with applied pottery, 13″ x 13″. *Courtesy of Foutz Trading Company, Shiprock, NM.*

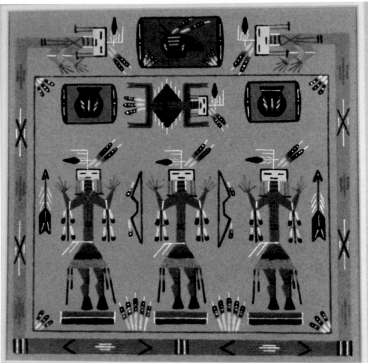

Nez (?). "Healing Gods," traditional, 12″ x 12″. *Courtesy of Shiprock Trading Company, Shiprock, NM.*

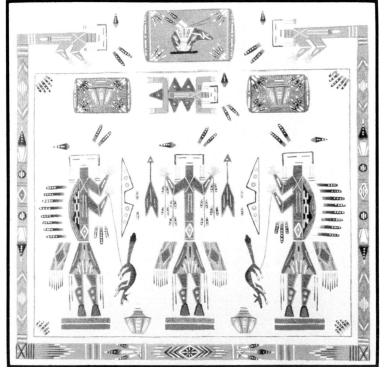

Nez. "Healing God and Camel God," traditional, 18″ x 18″. *Courtesy of Shiprock Trading Company, Shiprock, NM.*

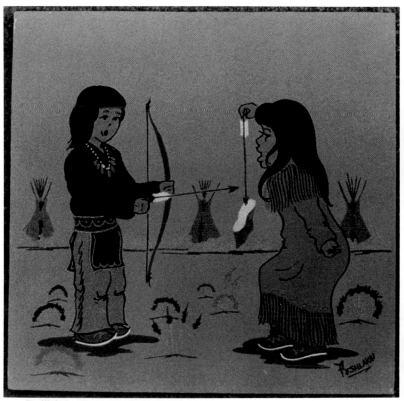

Peshlakai. "Bow and Arrow," 12″ x 12″. *Courtesy of Turquoise Lady, Albuquerque, NM.*

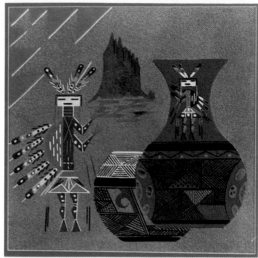

R. Ronald (?). Sand art, 13" x 13". *Courtesy of Foutz Trading Company, Shiprock, NM.*

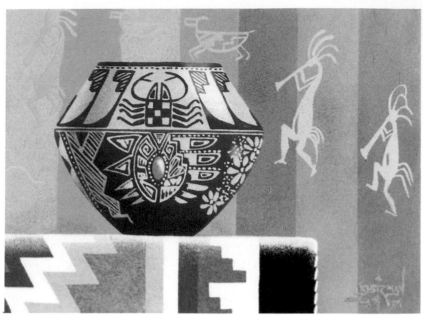

J. Sherman. Sand art, 12" x 16". *Courtesy of Foutz Trading Company, Shiprock, NM.*

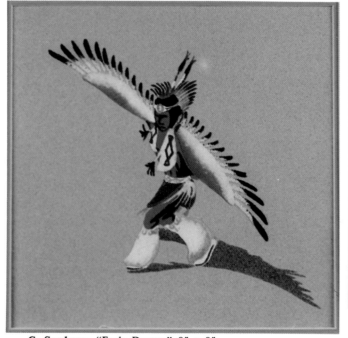

C. Sandman. "Eagle Dancer," 8" x 8". *Courtesy of Shiprock Trading Company, Shiprock, NM.*

J. Sherman. Sand art. *Courtesy of Bing Crosby's, Albuquerque.*

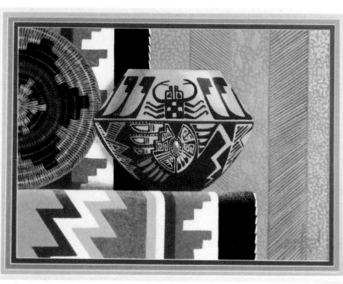

J. Sherman. Sand art, 12" x 16". *Courtesy of Foutz Trading Company, Shiprock, NM.*

J. Sherman. Sand art, 16" x 20". *Courtesy of Foutz Trading Company, Shiprock, NM.*

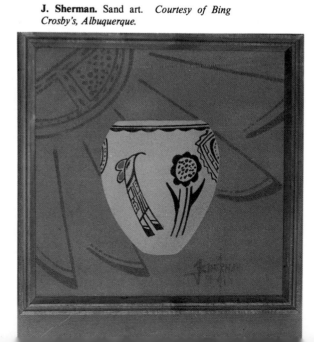

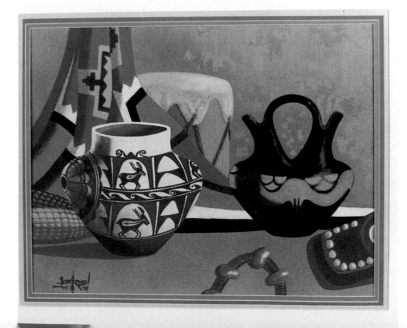

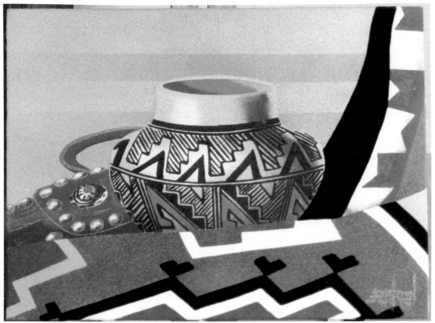

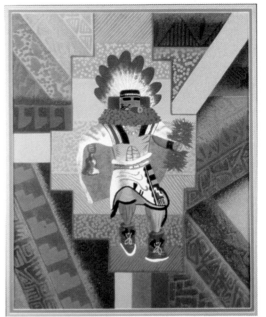

J. Sherman. Sand art, 12″ x 16″. *Courtesy of Foutz Trading Company, Shiprock, NM.*

Jerald Sherman. Triptych, each panel is 24″ x 8″. *Courtesy of Arroyo Trading Co., Farmington, NM.*

Jerald Sherman. Sand art, 20″ x 16″. *Courtesy of Arroyo Trading Co., Farmington, NM.*

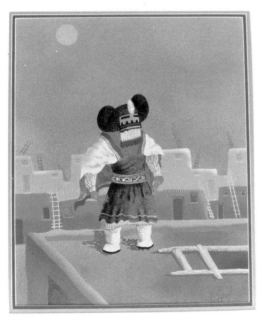

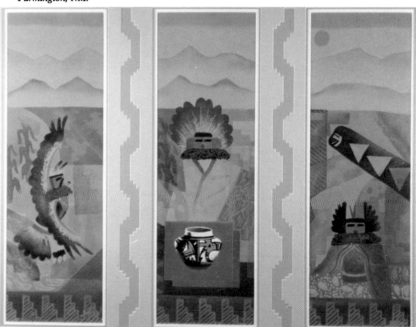

J. Sherman. "Kachina on Pueblo Roof," 20″ x 16″. *Courtesy of Arroyo Trading Co., Farmington, NM.*

Jerald Sherman. Sand art, 18″ x 24″. First Place winner at the 1990 O'Odham Tash Casa Grande Arts and Crafts Show. Raised carved pot. *Courtesy of Arroyo Trading Co., Farmington, NM.*

Jerald Sherman. Sand art, 20″ x 16″. *Courtesy of Arroyo Trading Co., Farmington, NM.*

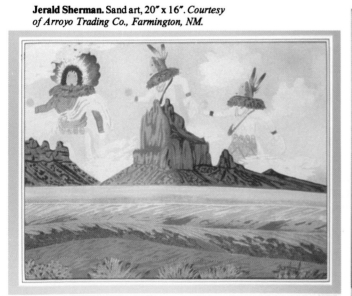

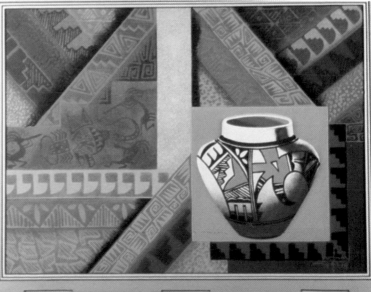

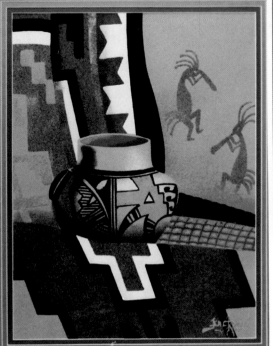

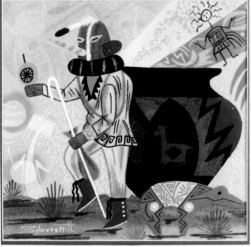

Keith Silversmith. Sand art, 12″ x 12″. *Courtesy of Foutz Trading Company, Shiprock, NM.*

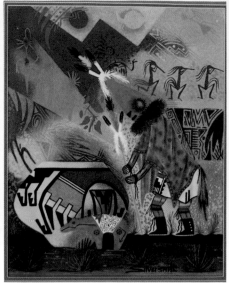

Keith Silversmith. "Kachina" . *Courtesy of Foutz Trading Company, Shiprock, NM.*

Jerald Sherman. Sand art, 16″ x 12″. *Courtesy of Foutz Trading Company, Shiprock, NM.*

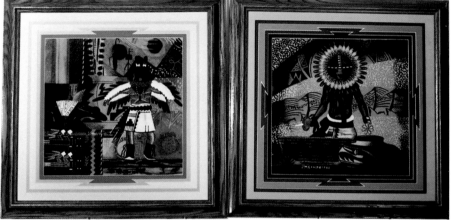

Keith Silversmith. Two sandpaintings. *Courtesy of Foutz Trading Company, Shiprock, NM.*

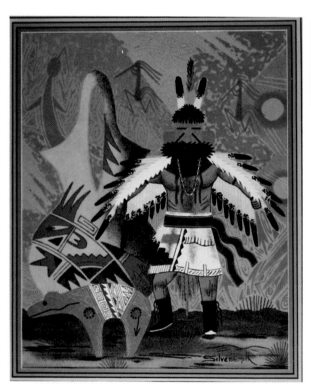

Keith Silversmith. Sand art, 20″ x 16″. *Courtesy of Foutz Trading Company, Shiprock, NM.*

Keith Silversmith. "Clown and Fetish Bear," 12″ x 12″. *Courtesy of Arroyo Trading Co., Farmington, NM.*

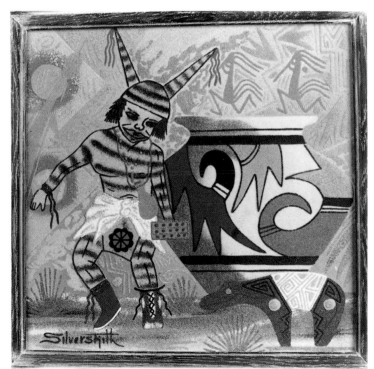

52

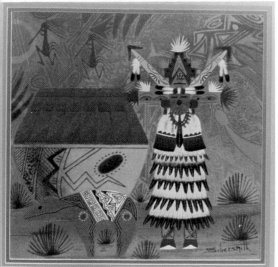

Keith Silversmith, 1989. Sand art, 16″ x 16″.
*Courtesy of Foutz Trading Company, Shiprock,
NM.*

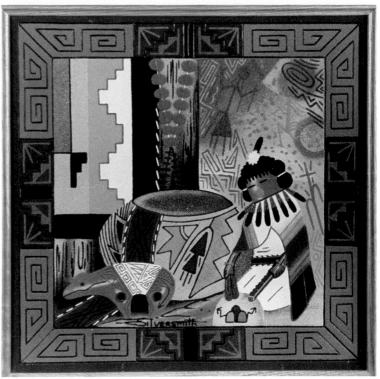

Keith Silversmith. Sand art, 16″ x 16″.
*Courtesy of Foutz Trading Company, Shiprock,
NM.*

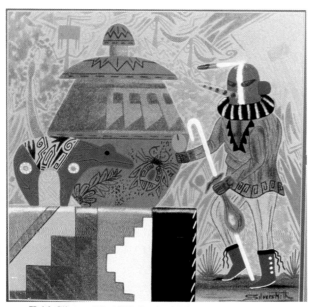

Keith Silversmith, 1989. Sand art, 18″ x 18″.
*Courtesy of Foutz Trading Company, Shiprock,
NM.*

Keith Silversmith, 1989. "Sunface Dancer,"
16″ x 16″. *Courtesy of Foutz Trading Company,
Shiprock, NM.*

Simpson. "Dancer," 12″ x 16″. *Courtesy of
Turquoise Lady, Albuquerque, NM.*

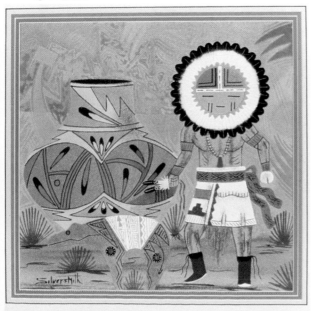

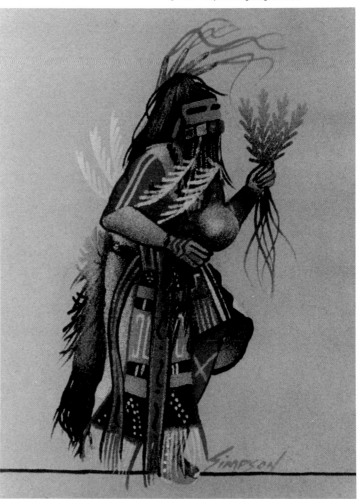

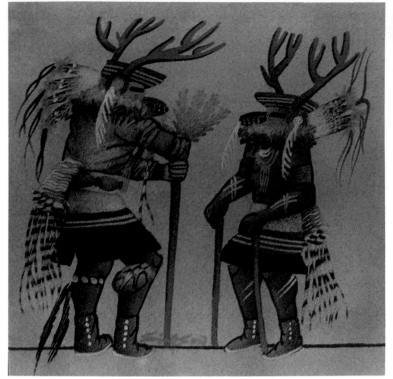

Simpson. "Deer Dancers," 12″ x 12″. *Courtesy of Turquoise Lady, Albuquerque, NM.*

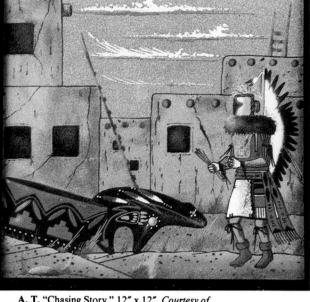

A. T. "Chasing Story," 12″ x 12″. *Courtesy of Shiprock Trading Company, Shiprock, NM.*

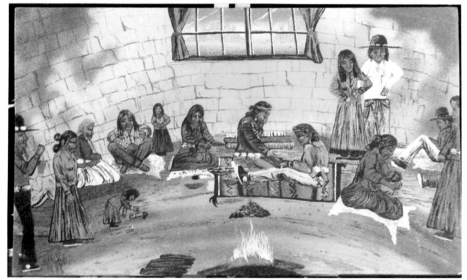

Lorenzo "Little River" Simpson, Farmington, 1982 . "Ceremonial Ritual," 18″ x 30″. *Courtesy of Shiprock Trading Company, Shiprock, NM.*

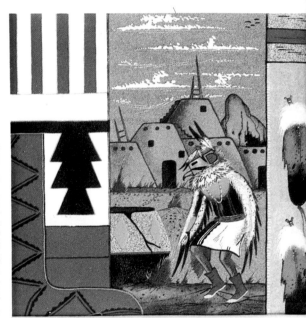

A. T. Sand art, 12″ x 12″. *Courtesy of Shiprock Trading Company, Shiprock, NM.*

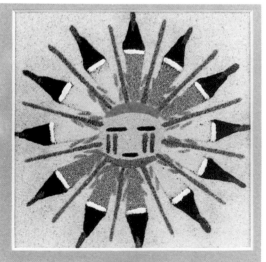

Judy Sun. "Sun," traditional, 4″ x 4″. *Courtesy of Foutz Trading Company, Shiprock, NM.*

E. Thomas. "Longhair," 13″ x 13″. *Courtesy of Foutz Trading Company, Shiprock, NM.*

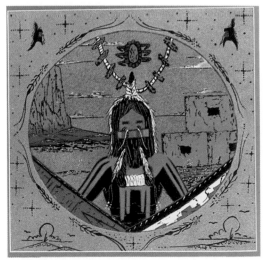

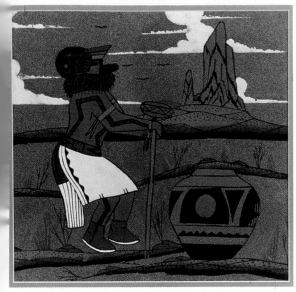

Eugene Thomas. "Ramhead Kachina," 12" x 12". *Courtesy of Foutz Trading Company, Shiprock, NM.*

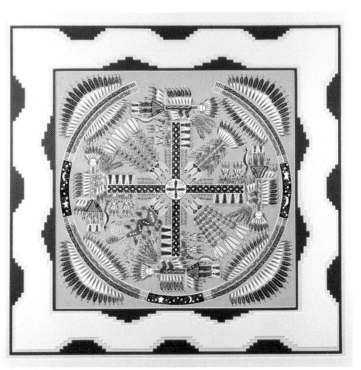

Malcus Thompson. Traditional sandpainting, 18" x 18". *Courtesy of Arroyo Trading Co., Farmington, NM.*

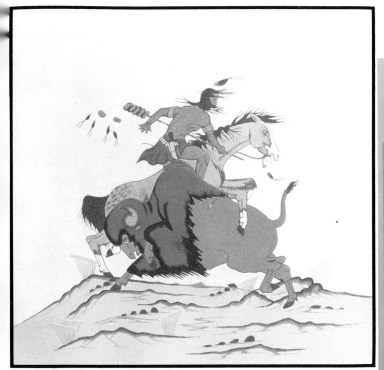

Thompson. "Buffalo, Horse, and Rider," 24" x 24". *Courtesy of Arroyo Trading Co., Farmington, NM.*

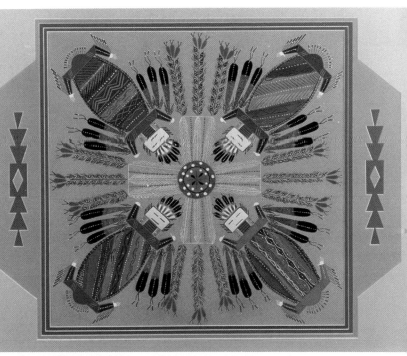

Malcus Thompson, Shiprock, NM. "Water Creatures and the Sacred Plant," traditional, 18" x 18". *Courtesy of Foutz Trading Company, Shiprock, NM.*

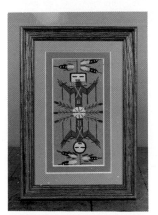

Toby (?). "Two Ways Yei," traditional. *Courtesy of The Indian Post, Allentown, PA.*

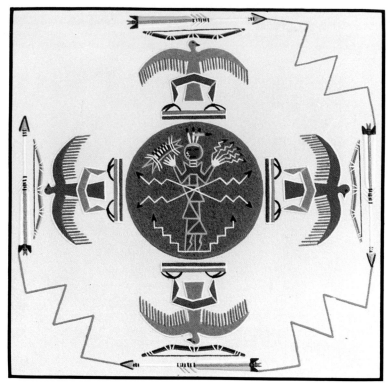

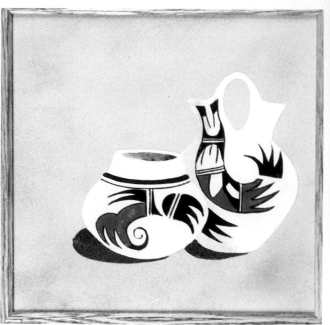

Amos Tom. Sand art, 12″ x 12″. *Courtesy of Shiprock Trading Company, Shiprock, NM.*

Mr. & Mrs. Jerry Ted Toledo, Cuba, NM. "Slayer of Alien God," 24″ x 24″. After a natural catastrophe (earthquake, hurricane, war, etc....anything not in the Path of Beauty and Harmony), the Navajo medicine man invoked the spirit of the Slayer of Alien Gods to aid the people and put an end to the calamity. The slayer, standing in the center of the harmonious turquoise circle of the sun, is covered with an armor of flint, lightning, and thunder. Since he can control all of these elements, he can also produce calamities at his will. Above his right hand is a club, a symbol of his power to produce earthquakes. In his left hand are five lightning arrows which he uses to perplex the clever minds of human beings, especially those who haven't yet gained control of the five senses through prayer and meditation. The four lofty eagles, each standing on a section of the Rainbow Guardian, are ever ready; to assist the slayer.

The bows, arrows, and lightning guard and guarantee the beneficial purpose of these mystic and sacred symbols so that an alien power may not use them. The painting is surrounded by a broken line with the exception of one opening which allows an entrance for a good spirit. *Courtesy of Arroyo Trading Co., Farmington, NM.*

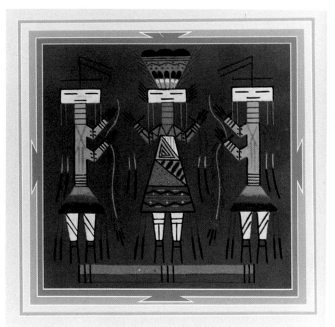

H. Tom, Newcomb, NM. "Holy Woman and Two Female Guardians," traditional, 13″ x 13″. *Courtesy of Foutz Trading Company, Shiprock, NM.*

Aaron Tom. Traditional sandpainting from the "Hilo-be" or Hail Way, 18″ x 18″. This chant is no longer performed. The last medicine man to perform it was Hosteen Klah, who knew an incredible total of six Ways. Here we see the heads of figures on both sides holding up the night. The white line around the edge represents the dawn. In the body are the various constellations, which were placed in the sky by Hasje-hasjin. Among them are No-ho-kos (the Big Dipper). The intertwined zig-zag lines are the Milky Way. Around the edge, top and bottom, are a number of guardians, including yellow male and blue female eagles, the antelope, and the bat, messengers of the night, shown here on a bed of corn pollen. *Courtesy of Shiprock Trading Company, Shiprock, NM.*

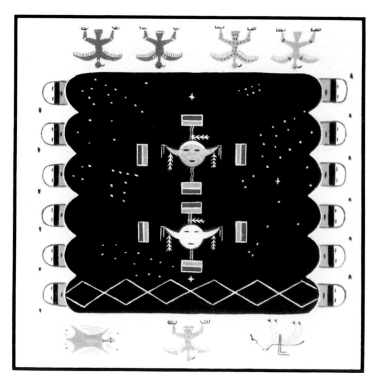

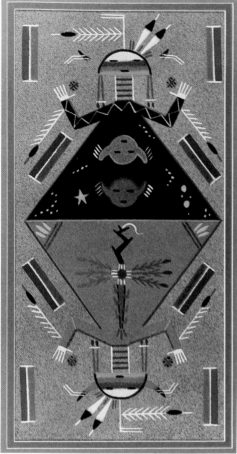

H. Tyler, 1989. "Father Sky and Mother Earth," traditional, 16″ x 8″. *Courtesy of Foutz Trading Company, Shiprock, NM.*

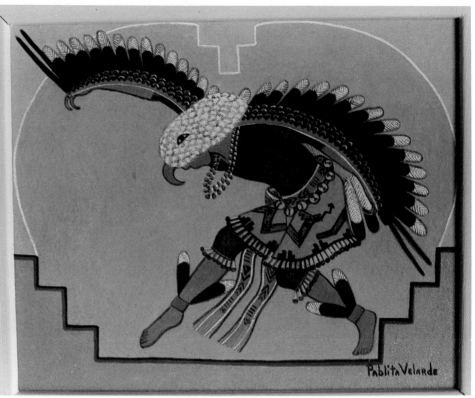

Pablito Velande. "Eagle Dancer."

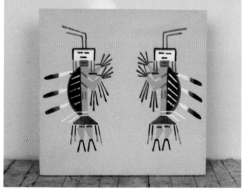

Tzozzie. "Two Camel Gods" . *Courtesy of The Indian Post, Allentown, PA.*

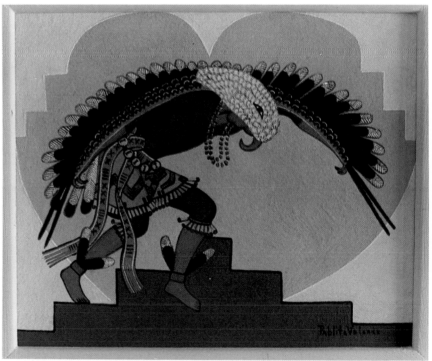

Pablito Velande. "Eagle Dancer."

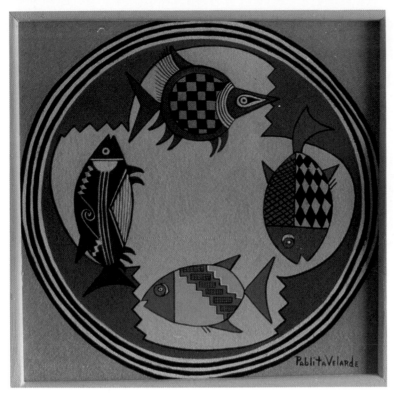

Pablito Velande. "Fish."

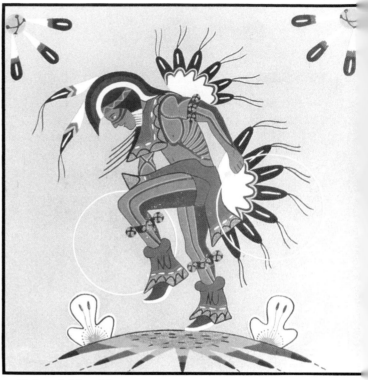

Chris and Mary Warren, Kirtland, NM. "Hoop Dancer," 24″ x 24″. May be symbolic of man's emergence from the underworld. It is danced today with Plains Indian costumes. *Courtesy of Arroyo Trading Co., Farmington, NM.*

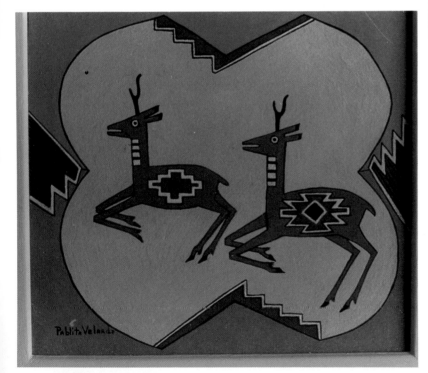

Pablito Velande. "Deer."

Avrila Watchman. "Rainbow People," 16″ x 8″ each. The curved bodies of people represent the arc of the rainbow. The skirts are symbolic of the Fire Dance. *Courtesy of Shiprock Trading Company, Shiprock, NM.*

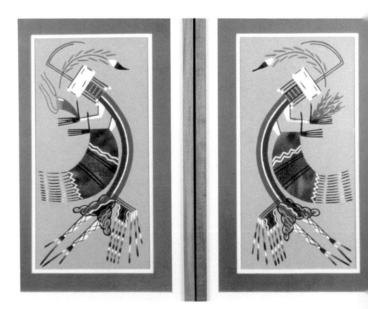

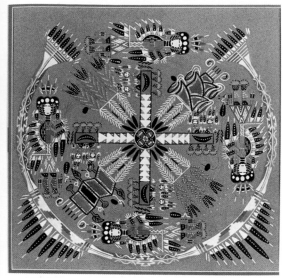

R. Weaver, 1989. "Whirling Log," 16″ x 16″.
Courtesy of Foutz Trading Company, Shiprock, NM.

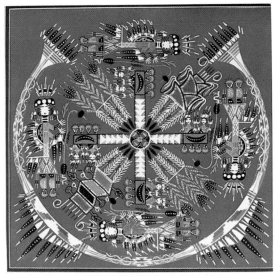

R. Weaver, 1989. "Whirling Log," 16″ x 16″.
Courtesy of Foutz Trading Company, Shiprock, NM.

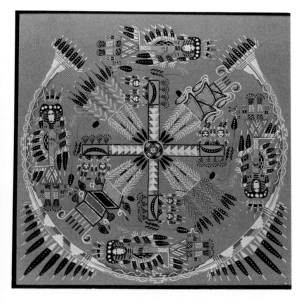

R. Weaver. "Whirling Log," 16″ x 16″.
Courtesy of Foutz Trading Company, Shiprock, NM. ·

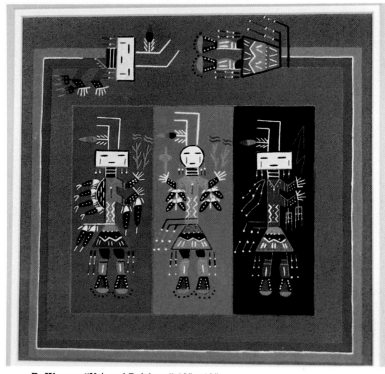

R. Weaver. "Yeis and Rainbow," 12″ x 12″.
Courtesy of Shiprock Trading Company, Shiprock, NM.

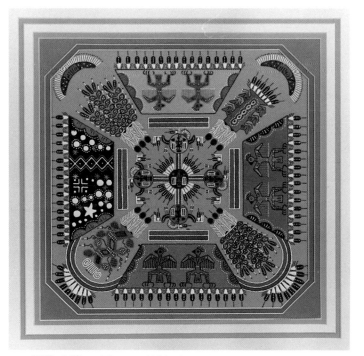

Wilfred. "Storm Figures and Lightning," 12″ x 12″. *Courtesy of Foutz Trading Company, Shiprock, NM.*

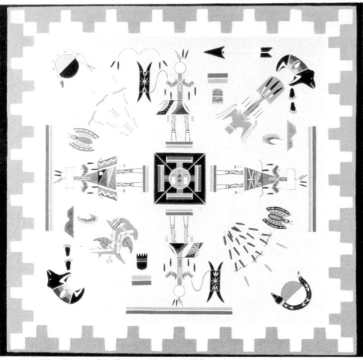

Yaz-He. "Home of the Bear and Snake," 18″ x 18″. *Courtesy of Shiprock Trading Company, Shiprock, NM.*

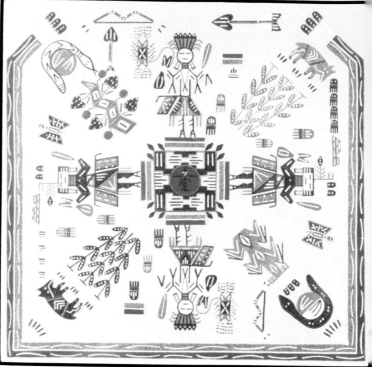

Yazzie. "Home of the Bear and Snake," traditional, 18″ x 18″. *Courtesy of Shiprock Trading Company, Shiprock, NM.*

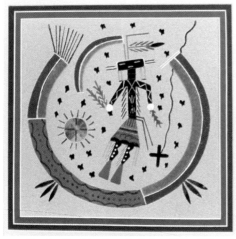

Yazzie. Traditional sandpainting, 12″ x 12″. *Courtesy of Foutz Trading Company, Shiprock, NM.*

Yazzie. Sand art, 12″ x 12″. *Courtesy of Foutz Trading Company, Shiprock, NM.*

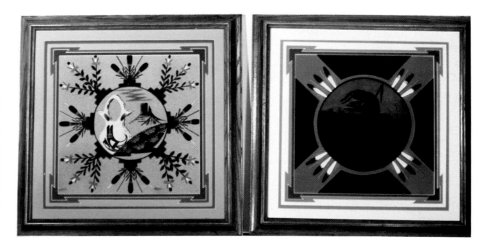

Yazzie. Two sandpaintings . *Courtesy of Foutz Trading Company, Shiprock, NM.*

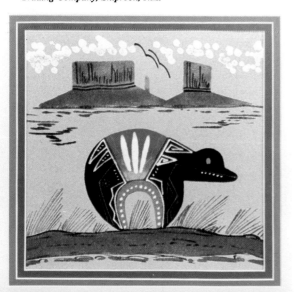

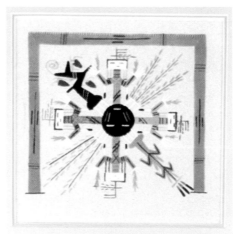

Yazzie. "Plants and Yeis," traditional, 8″ x 8″. *Courtesy of Shiprock Trading Company, Shiprock, NM.*

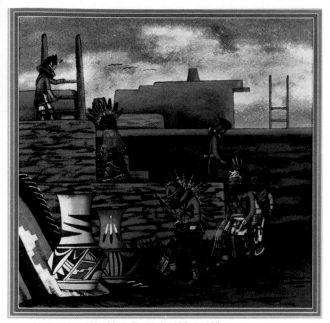

A. Yazzie. "Kachina Dance," 18″ x 18″. *Courtesy of Foutz Trading Company, Shiprock, NM.*

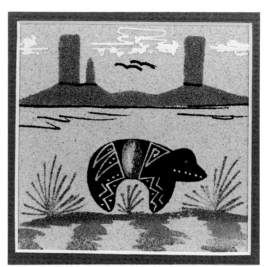

Berta Yazzie. "Bear Fetish," 4″ x 4″. *Courtesy of Foutz Trading Company, Shiprock, NM.*

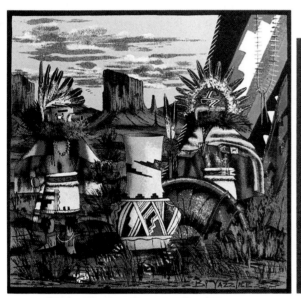

A. Yazzie. "Kachina Dancer," 18″ x 18″. *Courtesy of Arroyo Trading Co., Farmington, NM.*

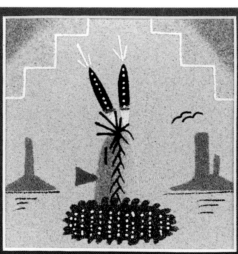

Berta Yazzie. "Yei-Be-Chai," 4″ x 4″. *Courtesy of Foutz Trading Company, Shiprock, NM.*

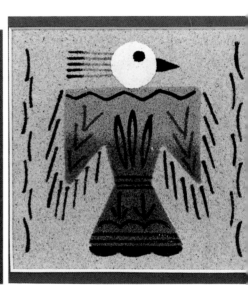

Berta Yazzie. "Thunderbird," traditional style, 4″ x 4″. *Courtesy of Foutz Trading Company, Shiprock, NM.*

Berta Yazzie. "Sun Coyote," traditional, 4″ x 4″. *Courtesy of Foutz Trading Company, Shiprock, NM.*

Berta Yazzie. "Chirchua Sun," traditional, 4″ x 4″. *Courtesy of Foutz Trading Company, Shiprock, NM.*

Berta Yazzie. Sand art, 4″ x 4″. *Courtesy of Foutz Trading Company, Shiprock, NM.*

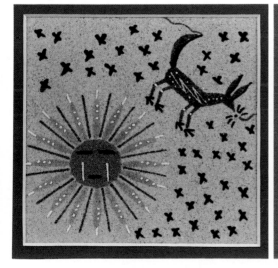

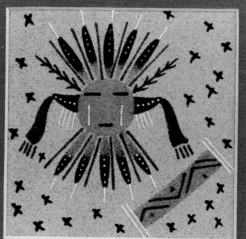

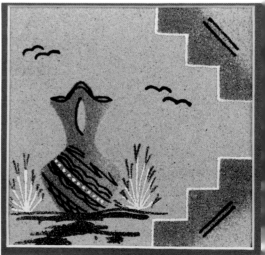

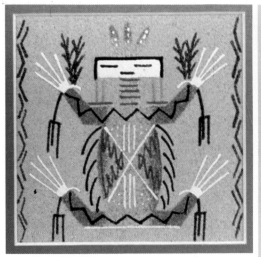

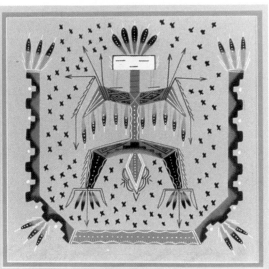

Berta Yazzie. "Big Thunder," 13″ x 13″. *Courtesy of Foutz Trading Company, Shiprock, NM.*

Berta Yazzie. "Water Creature," traditional figure, 4″ x 4″. *Courtesy of Foutz Trading Company, Shiprock, NM.*

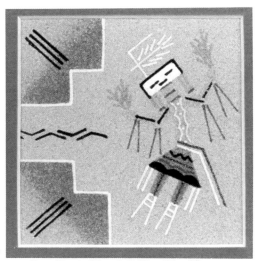

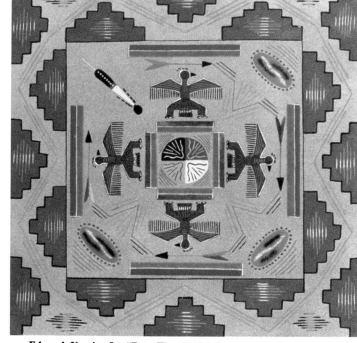

Berta Yazzie. "Female Yei," traditional figure, 4″ x 4″. *Courtesy of Foutz Trading Company, Shiprock, NM.*

Edward Yazzie, Jr. "Four Thunderbirds," traditional, 18″ x 18″. *Courtesy of Arroyo Trading Co., Farmington, NM.*

Edward "Sonny" Yazzie, Jr. "Coyote Stealing Fire," traditional, 18″ x 18″. *Courtesy of Arroyo Trading Co., Farmington, NM.*

Berta Yazzie. "Big Thunder," 4″ x 4″. *Courtesy of Foutz Trading Company, Shiprock, NM.*

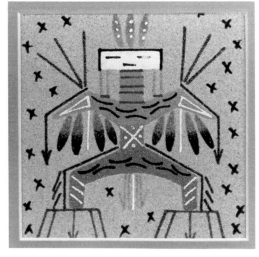

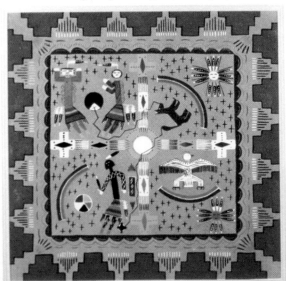

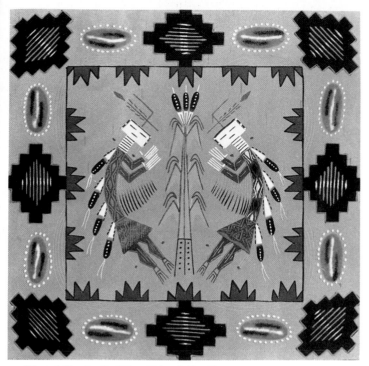

Edward Yazzie, Jr. "Two Yei and Corn," traditional, 18″ x 18″. *Courtesy of Arroyo Trading Co., Farmington, NM.*

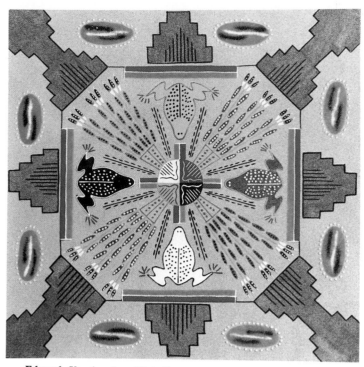

Edward Yazzie, Jr., Waterflow, NM. "Mother Earth and Father Sky," traditional, 18″ x 18″. *Courtesy of Arroyo Trading Co., Farmington, NM.*

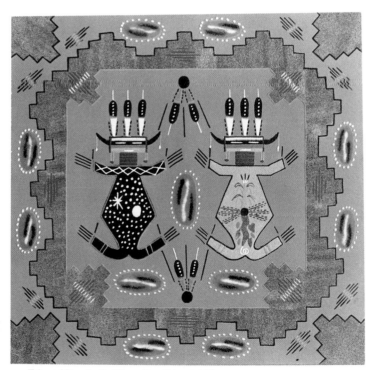

Edward Yazzie, Jr. "Frogs," traditional, 18″ x 18″. *Courtesy of Arroyo Trading Co., Farmington, NM.*

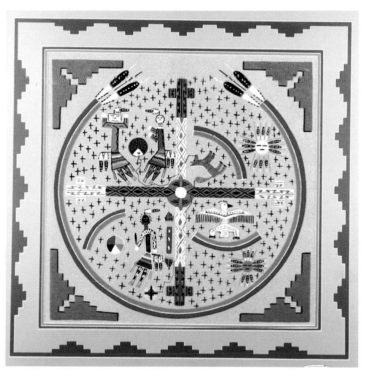

Edward "Sonny" Yazzie, Jr. "Coyote Stealing Fire," traditional, 18″ x 18″. *Courtesy of Arroyo Trading Co., Farmington, NM.*

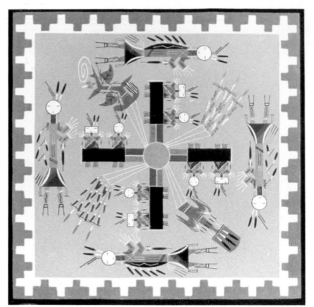

G. Yazzie. "Whirling Log," traditional, 12″ x 12″. *Courtesy of Arroyo Trading Co., Farmington, NM.*

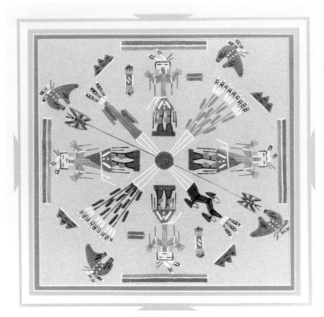

Unknown artist. "Home of the Bears," traditional, 13″ x 13″. *Courtesy of Foutz Trading Company, Shiprock, NM.*

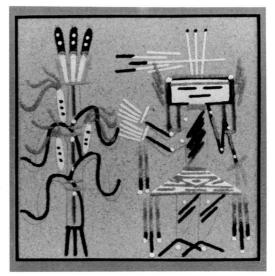

L. Yonnie. "Seed Blessing," 4″ x 4″. *Courtesy of Foutz Trading Company, Shiprock, NM.*

L. Yonnie. "Humpback Yei," 4″ x 4″. *Courtesy of Foutz Trading Company, Shiprock, NM.*

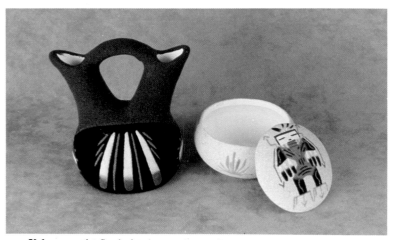

Unknown artist. Sandpainted vase and covered bowl. *Courtesy of Arroyo Trading Co., Farmington, NM.*

Unknown artist. Cast skull with sandpainting. *Courtesy of Foutz Trading Company, Shiprock, NM.*

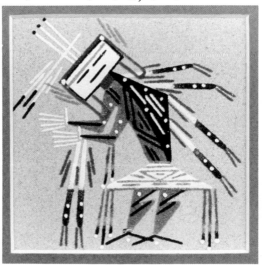

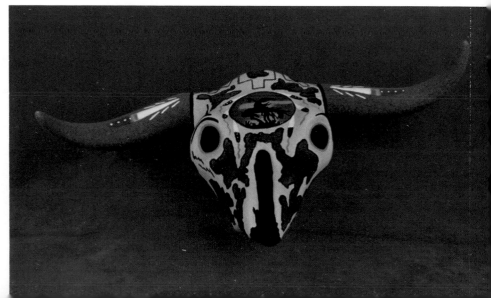